IMAGES
of America

MARICOPA

IMAGES
of America

MARICOPA

Patricia Brock and the
Maricopa Historical Society

ARCADIA
PUBLISHING

Published by Arcadia Publishing
Charleston, South Carolina

Printed in the United States of America

Library of Congress Control Number: 2010940822

For all general information, please contact Arcadia Publishing:
Telephone 843-853-2070
Fax 843-853-0044
E-mail sales@arcadiapublishing.com
For customer service and orders:
Toll-Free 1-888-313-2665

Visit us on the Internet at www.arcadiapublishing.com

Perry Williams arrived in Maricopa at a time when it was just beginning to build its infrastructure as a railroad junction. Like most entrepreneurs, he recognized the opportunities available and was not afraid to take a risk. He immediately put his financial resources and experience to work, building a hotel and stocking it with a nest of wildcats and beautiful basketry. He invested in large holdings of cheap Maricopa land and bought up several mines. He served as the first justice of the peace in 1890 and became its first mayor in 1891. (Maricopa Historical Society.)

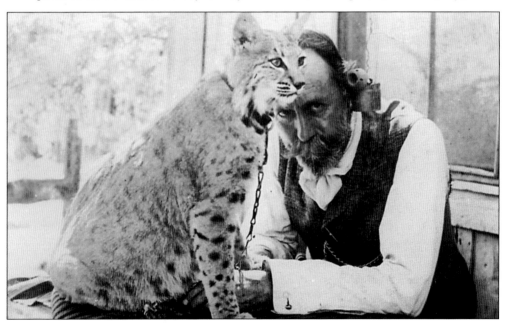

CONTENTS

ACKNOWLEDGMENTS

This venture would have been impossible if not for the preservation of the many photographs, the written and spoken stories, and the historical accounts of Maricopa's citizens. A debt of gratitude is owed to E. O. Stratton, a bookkeeper at Maricopa Wells who described its physical structure in detail, and Charles Clark, a telegrapher at the Wells who gave it voice. The book written by the Conklings, *Butterfield Overland Mail*, was invaluable, and so was Waterman Ownsby's account of his experiences of the first Butterfield stagecoach journey across country.

The greatest contributor of Maricopa's second location, even though it survived only a short time, is undoubtedly the newspapers of the time and other archived papers that provided detailed accounts of Maricopaville's almost daily progress.

However, there is much information about Maricopa's third and final location as a junction. Thanks go to David Myrick's definitive book, *Railroads of Arizona*, and the many archived newspapers from that time. Maricopa also owes much gratitude to the many railroad families who preserved and shared their memories and stories, including the following: Perry Williams, Susie Smith, Dr. Melvin Drake, Donald DeHart, and especially the Arthur Deal family, who gave us personal interviews and speaking engagements.

Thank you to the many farming families and Ak-Chin people who shared their many photographs, stories, and memories. I would also like to thank Leona Carlyle Kakar and Elaine Peters, the director of the eco-museum; they shared Ak-Chin's old and beautiful buildings and history. A debt of gratitude goes to the following people who took the time to share Maricopa's rich history with school and city statistics and photographs: Paul Jepson, Shannon Hull, Patricia Miller, and Joyce Hollis of InMaricopa.com (published by Scott Bartle). Most importantly, thank you to Rex Brock for his tireless hours of research and assistance. Unless otherwise noted, all images appear courtesy of the book *Reflections of a Desert Town* and the Maricopa Historical Society.

INTRODUCTION

A short drive 16 miles south of Interstate 10 and Ahwatukee is one of the oldest and most historic communities in the state of Arizona. Maricopa is hidden in the middle of the Sonoran Desert, surrounded by mountain ranges, which include the beautiful Sierra Estrellas, Palo Verde, Saddleback Mountains, and Haley Hills. It is unique in that it has had three locations over the years, and each move played a major role in the growth and development of the Southwest. Located on the southern banks of the Gila River, Maricopa Wells (Maricopa's first location) was a haven for thousands of immigrants who followed the southern trail in the 1800s across Arizona to California's gold fields. The nearby Gila River flowed freely, with dozens of species of wildlife that included geese, ducks, beaver, and plenty of fish. Cottonwood trees and willows bordered and draped its banks, and in some spots, the woodlands were so thick that the river was not visible.

Maricopa Wells's neighbors to the north, the peaceful Pima and Maricopa farmers, who were located on the Gila River Reservation, helped contribute greatly to the settlement and growth of Arizona Territory and the Southwest in the 1800s. Their farming expertise supplied an abundance of food not only for local citizens but also for those in the military and those that traveled through this desolate area in the 1800s. After the California Gold Rush, Pimas frequently assisted parties of explorers and travelers and often protected them from the Apaches and other warlike tribes. Maricopa borrowed its name from the friendly Maricopas who escaped the not so friendly tribes along the Colorado River.

Maricopa was born in the heart of the Gila River Valley, surrounded by lush agricultural lands that were nurtured centuries ago by its first inhabitants, the Hohokam. The Hohokam dug by hand the largest prehistoric irrigation system in North America, stretching more than 250 miles. The canals, slanting perfectly for gravity, were 30 to 40 feet wide and 15 feet deep in some places and were dug using sticks and stone hoes. The Gila River also was home to the Akimel O'Otham (Pimas), who are most likely direct descendants of the ancient Hohokam. Today the rich agricultural heritage of the Hohokam continues to survive and thrive with the Pima and Tohono O'Odhams' 16,000-acre Ak-Chin Farms, which is located south of Maricopa. It is one of the largest and most successful farming enterprises in the United States.

Maricopa Wells provided water not only for residents at Maricopa Wells but also for travelers and explorers who ventured through this sparsely populated area searching for gold or lost souls centuries ago. Marcos de Niza, thought to be the first white man to travel into the Gila River and Maricopa Wells area in 1539, was a missionary and explorer. The Pimas were aware of his arrival and welcomed him with food and water. Marcos de Niza described their farmlands as one almost continuous garden that lined both sides of the Gila River from west of Florence to Pima Butte (near Maricopa Wells).

In 1540, when leading an expedition through Arizona searching for the seven cities of Cibola that de Niza had described the previous year, Spanish conquistador Francisco Vázquez de Coronado traveled the Gila River area. Father Kino, in 1694, followed the same river with the purpose of

building missions and helping Native Americans. On his first trip, Father Kino was amazed to see a huge house as big as a castle in the middle of the desert (Casa Grande Ruins), and on his second trip, two similar but smaller houses in ruins were discovered.

Juan Bautista de Anza and Fr. Jacobo Sedelmayr also described the big houses while traveling near the Gila River. One of the houses Kino and Sedelmayr mentioned was the ruins of Casa Blanca, which was located about 2 miles southwest of Sweetwater. The second ruin described was at the Pima village of Sutaquisón, near Pima Butte.

Maricopa Wells provided water for the trappers and traders who invaded the Gila River region in 1821 trapping beavers, and in 1846, Kit Carson guided Gen. Stephen Kearny's Army of the West across Arizona, stopping at the Wells. Following on the heels of Kearny and his men came the Mormon Battalion and Col. Philip St. George Cooke, who built a wagon road through southern Arizona. They rested at Wells and replenished their supplies there. The Oatman family and others stopped at the Wells in 1851. They were encouraged to wait a few days at the Wells because of Mohave warriors in the area but refused. About 40 miles from Maricopa Wells, near Painted Rock, Mohaves massacred almost the entire family.

Between 1857 and 1858, Wells became a major stagecoach relay station for the first organized semi-public transportation in Arizona, the San Antonio and San Diego Mail Line, and in the following year, it served in the same capacity for the Butterfield Overland Mail Line, which operated between 1858 and 1861. When people began to settle the Salt River Valley in Phoenix, they had two towns in which to buy supplies, Maricopa Wells or Wickenburg. Frequently, they traveled out to the Wells for supplies. Almost everyone who lived at the Wells were employed by the stagecoach line and trading center.

Maricopa Wells was allegedly headquarters for the U.S. Customs Office in 1868, headed by Charles DeBrille Poston. The station was purchased in the 1870s by James A. Moore and partner Larkin W. Carr, and it was during these years that it enjoyed its most prosperous times. This was partly due to the construction of a road to the north that provided the first Arizona Mail Route into Phoenix. Whether traveling from Tucson to Yuma, up north to the mines, or to the Phoenix area, all roads converged at Maricopa Wells.

Maricopa Wells dropped the second part of its name in 1879 and moved its telegraph office and post office 8 miles directly south in order to hook up with the Southern Pacific Railroad and serve as a junction for two railroads. This branch was purported to serve not only the Salt River Valley but also the mines and towns up north. Newspapers of the day predicted great success and opportunities for this new site of "Maricopaville," with its hundreds of people, fine hotels, theaters, and wide variety of businesses to satisfy the needs of the most persnickety of people. The newspapers compared its sudden eruption from the desert floor to the gold rush towns of California. It was suggested that it would be an ideal place to move the territorial capital of Arizona.

However, this little city in the middle of the desert that literally rose up overnight was never a junction for two railroads, nor did it reign as the capital of Arizona. It did share, with Casa Grande, the title of being the freighting distribution center of Arizona.

Daily runs of stagecoaches delivered mail into the Phoenix area, and the citizens of Prescott had one daily and one triweekly stagecoach run to that point. However, its life as a terminus was doomed when Tempe protested and demanded they be a part of the new railroad branch. The territorial government heard their voices, and new plans for the branch included Kyrene and Tempe—and another move for Maricopa.

Maricopa's final move took it 3 miles directly east so that the town could take on the challenge of being a junction for two railroads, the Southern Pacific Railroad and the Maricopa and Phoenix Railroad (M&P, the Arizona Eastern Railroad as of 1910). The M&P made its maiden journey on July 4, 1887, into the Salt River Valley to receive a huge celebration that included parades, bands, speeches, and people lined up along its route from Kyrene and Tempe into Phoenix.

Thus began Maricopa's life as a railroad junction that played host to not only Arizona dignitaries but also to Presidents William McKinley and Theodore Roosevelt, as well as the famous heavy-weight boxer John L. Sullivan. One of its hotels advertised honeymoon suites that became popular

with the newly wed couples in the Phoenix area, and another employed a nest of wildcats and bell ringers to attract attention and promote business. Hundreds of people congregated at the Maricopa Railroad Station and hotels that lined the tracks, waiting for their train connection to the east, west, or up north. The coming of the railroad revolutionized the economy of Arizona for the next 40 years. Merchandise traveled into the Phoenix area by rail instead of wagons, and local products reached markets in the east and west more quickly.

After much flooding, destruction, and rebuilding of lines, the railroad redirected a line through Picacho into the Phoenix area, and Maricopa lost its importance as a junction but found its desert lands were ideal for farming. Maricopa's raw desert was cultivated into rows of green plants, offering up snowy white blossoms of cotton between 1948 and the 1960s. Cotton fields lined the roadways and earned the Maricopa/Stanfield area the title of having the highest average cotton yield of any large area in the world from Central Arizona Project research studies. Throughout the years, cattle became an important industry, and farmers experimented with and grew a variety of other crops including alfalfa, peas, melons, citrus, and pecans.

When Maricopa incorporated in 2003 as the 88th Arizona city, the 2000 census listed it with a population of 1,040. During the following two years, its population exploded to 15,934, earning it the title of one of the fastest growing cities in the United States.

Today that population has more than doubled again. Maricopa's new citizens are international and depict the same cultural diversity as its birthplace at Maricopa Wells. They are world-class musicians, composers, artists, quilt makers, collectors, pilots, lawyers, accountants, farmers, painters and decorators, salespersons, teachers, investors, inventors, and doctors. They are deeply involved in creating a city and paying forward to enrich the lives of everyone.

Maricopa is a community that not only witnessed history but also lived it. Its early pioneers built a road for the first Arizona Mail Line, which went from Maricopa Wells into the Phoenix area, and they also sent the first train from Maricopa to the Salt River Valley, which allowed Kyrene, Tempe, Mesa, and Phoenix to connect with the rest of the world. Maricopa witnessed and played host to the first transcontinental flight across the nation in 1911 and also provided a car for Carl Hayden to chase a couple of train robbers across the desert in 1910, earning him a reputation that took him to Washington, D.C., as one of America's longest serving congressmen.

Maricopa, which is the only city in the nation bordered by two Native American communities, continues to honor and celebrate this cultural diversity and embraces the American ingenuity and pioneering spirit that have been an integral part of its community for centuries. Maricopa has grown tremendously but has not lost its identity or sense of community. Today it continues to celebrate its cultural diversity, to provide a state-of-the-art library, to develop different parks and places for recreation, to honor its many churches, to supply a variety of service clubs, and to nourish its energetic and caring people. Rich in history, innate beauty, and friendly people, Maricopa is a fantastic place to raise a family, build a business, or just embrace the warm winter climate on a patio and watch the incredible desert sunset spread out in an array of bright colors across the evening sky and then gently disappear behind the rugged western mountains.

One

MARICOPA WELLS
BUTTERFIELD OVERLAND
STAGE STATION

The words of James M. Barney in an *Arizona Highways* article in 1936 described the tiny frontier settlement of Maricopa Wells as the following: "No more historic spot exists in all this Southwestern country than the site that once—in a now far distant day—was the lively and flourishing stage station of Maricopa Wells. In its day—a day of glory and romance—Maricopa Wells was the vibrant center of business activity for the entire Territory of Arizona."

Maricopa Wells, a beacon in the desolate and sparsely populated Arizona Territory in the 1850s, lit up the floor of the desert for miles and promised refuge for the thousands of settlers who were courageous enough to embark upon its unbridled lands in the 1800s. This oasis in the desert, located on the southern banks of the Gila River, was approximately 8 miles north of present-day Maricopa and west of Pima Butte. It was Maricopa's first location.

There were few white settlers living in Arizona in the early 1800s and even less well-defined roads. Gen. Stephen Kearny's Army of the West took the roughness off a disconnected trail across Southern Arizona by dragging two small cannons, pulled by mules and horses, in 1846. The Pima and Maricopas were living and farming along the Gila River from Sacaton to the Gila River Crossing, and the nearest white neighbor to the Wells was Henry Morgan, who took up residence along the Gila River in 1864. Morgan spent more than 20 years ferrying passengers and freight across the Gila River, and in the process, he allegedly wore out or lost four ferryboats.

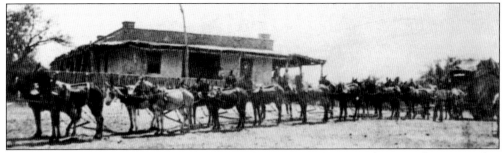

Great freight trains that had 3 or 4 wagons, with 8 to 20 mules on each, were often camped at the Wells. Starting to the north of Maricopa Wells, these trains carried goods from east to west and stopped at most key points in northern Arizona. Immigrants and military troops used the area for camping grounds, wagon repairs, and supplies.

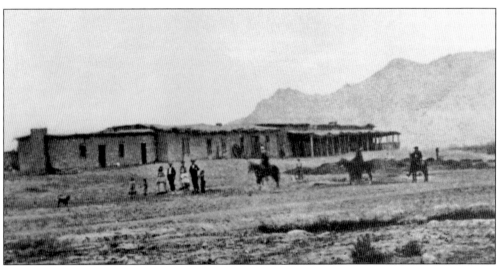

The town of Maricopa Wells was a fort-like structure that consisted of one building, but this building was able to contain the entire town, which totaled about 2 acres. The store, saloon, office space, and living quarters faced the road, and the right side contained the hotel and restaurant that served meals for $1. On the opposite side were stables, a blacksmith, and a shop. Around the station was a green grassy valley that was covered with considerable mesquite timber.

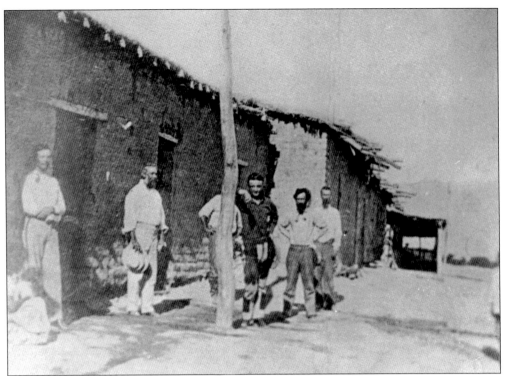

In 1873, a military telegraph line connected Yuma to Maricopa Wells, Tucson, and up north to Phoenix. This instant communication over vast distances opened up lines of telecommunications and closed the distance between communities, states, and the nation. It not only allowed and facilitated the coordination of military and law enforcement but also aided in the economy of the territory through faster and more efficient communication. (Arizona Historical Foundation.)

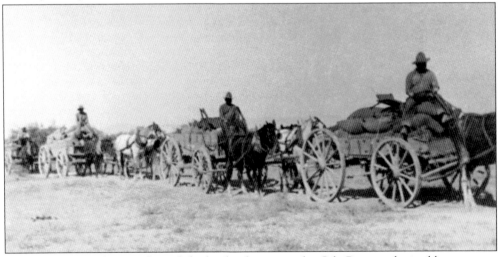

The Maricopas and Pimas farmed the lands adjacent to the Gila River and raised beans, corn, pumpkins, watermelons, muskmelons, cotton, and their principal crop, wheat, in the 1800s. Fr. Bonaventure Oblasser described the Pima fields from Florence to the Estrella Mountains as a continuous agricultural scene with one field following another. He stated that it "presents the appearance of one immense garden . . . and all under irrigation."

Before the dams diverted its waters, the Gila River was one of only three rivers in Arizona that had a continuing east-west flow of water. The Colorado and the Salt Rivers are the other two. The Gila River is 630 miles in length and rises in Western New Mexico, flowing westward into Arizona through the town of Safford and along the southern edge of the Gila Mountains. Then it crosses the Gila Indian Reservation, which is just north of Maricopa Wells, and makes a great curve around the northern end of the Estrella Mountains, at which point the Salt River joins it. Next it dips sharply southward and turns west near Gila Bend, paralleling the railroad tracks, where it eventually empties into the Colorado River. The Santa Cruz River and Santa Rosa and Vekol Washes take on waters from the south and empty into the Gila River near Maricopa Wells.

At the southwestern end of the Sierra Estrella is a stone face that the Pimas believed was a profile of their god, whom they called "Montezuma." There are many legends about this god, and one indicates that Montezuma was the name of a great king and lawgiver who ruled over a vast empire and was buried at the southern end of the mountains. During times of water shortages, the Pimas looked toward this god to send rain so that the Gila might once again fill with water for their crops. Throughout the years, this was an important landmark for travelers, and those who passed under the sleeping stone edifice anticipated the moment and marveled at its creation.

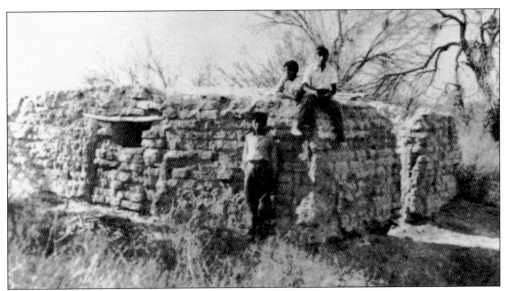

The final chapter closed for Maricopa Wells in 1879 with the building of the Southern Pacific Railroad just south of Maricopa Wells. Today there are few remnants left to bear witness to this once busy and important Butterfield Stage station. However, it does leave a legacy through several records, diaries, and journals kept by the many travelers who explored its land hundreds of years ago. The photograph above depicts the remains of what was once a jewel in the desert—a beacon of light—that offered a promise of direction and survival to those who ventured to its locale. These three young unidentified explorers probably found plenty of pottery, artifacts, and vestiges in 1939 from Maricopa Wells's days of glory and importance. Below, Eddie Jay Farrell (left) and Russell Hulse also probably found hints of an earlier civilization in the 1950s. Today this area is part of the Gila River Reservation and is closed to the public.

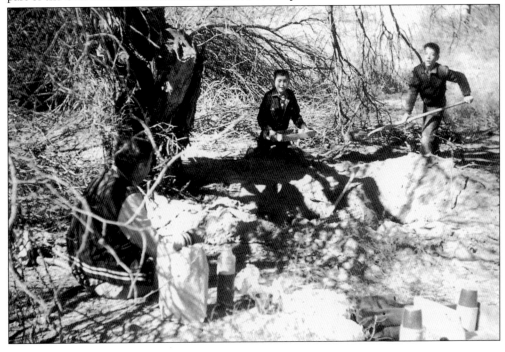

Two

MARICOPAVILLE
FREIGHTING DISTRIBUTION CENTER

The first transcontinental Butterfield Overland Mail line had an impact on connecting the west with the east between 1858 and 1861, but without doubt, it was the first transcontinental railroad that provided the greatest momentum to the westward movement in 1869. The railroad not only facilitated the movement of huge amounts of bulk supplies, gold, people, animals, and other goods across the country but also did it more efficiently.

By May 1879, the iron horse had arrived at the doors of Southern Arizona, and Maricopa Wells had already moved its post office and telegraph office approximately 8 miles south to take on the responsibility of a busy railroad junction. This location, about 30 miles directly south of Phoenix, was purported to serve as the junction for the Southern Pacific Railroad and the newly proposed Maricopa and Phoenix Railroad branch into Phoenix.

California investors got on board the promotional California train that led to Maricopaville's special auction in 1879 and spent thousands of dollars for land. Two lots sold for $1,000 each. Five years prior to this sale, the whole town site of Phoenix was valued at $550, with downtown lots selling from $7 to $11 each. The *Phoenix Herald* predicted a great future for Maricopaville. In April 1879, the *Arizona Sentinel* also confirmed Maricopaville's future as "destined to be a brilliant one as a shipping point for all freights produced by the rich agricultural sections bordering the Gila and Salt Rivers and the great grazing and mining regions from the north, northeast, and the Papagos from the south."

The building boom began immediately at Maricopaville. Warehouses and hotels virtually sprouted up overnight, and wagons transported freight from all over the territory to Maricopaville. This building frenzy resembled the gold rush towns in California. Four- and six-horse Concord coaches to and from the Salt River Valley provided passenger service, but it was the freighting business that dominated the economy. However, Tempe protested and demanded that they receive railroad services, too. The powers at the territorial capital recognized their concerns and drew up new plans that relocated the placement of the line to include Tempe. Thus Maricopa moved again.

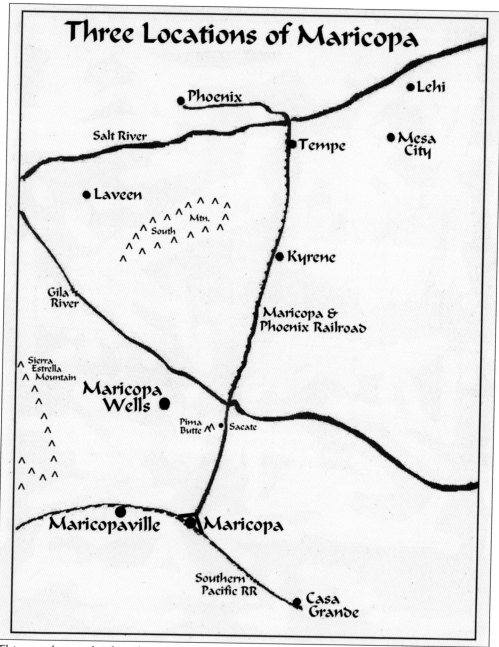

Three Locations of Maricopa

This map depicts the three locations of Maricopa. Maricopa Wells, located 8 miles northwest of Maricopa between 1857 and 1879, was an important stage station, trading center, and refuge for thousands of travelers during the 19th century. Maricopaville, which was in existence between 1879 and 1886, put down stakes 3 miles west of present-day Maricopa but never served as a junction for two railroads or as the capital of Arizona, which was suggested by one newspaper. However, it did serve as a railroad freighting distribution center and a boomtown with over 500 residents at one time. From 1887 to the 1930s, Maricopa Junction, which is its present location, served as a railroad junction for east-west travelers and those heading up north to Phoenix. (Rex Brock.)

Southern Pacific Railroad hired 1,300 railroad employees to lay railroad tracks across Southern Arizona in 1879, and 1,100 of them were Chinese Americans who worked long hours for $1 a day. They were able to lay more than 1.25 miles of track per day that eventually connected the East Coast with the West Coast and made travel more comfortable, faster, efficient, and economical during the 1800s and 1900s. It took less than five months to lay tracks from Yuma to the Maricopa Summit, located 17 miles west of Maricopaville. After leaving Maricopa Summit, the tracks ran 785 feet to the top of a hill, and at that point, a 5-mile curve began that is thought to be the longest continuous railroad curve in the world. (Irac Mendez.)

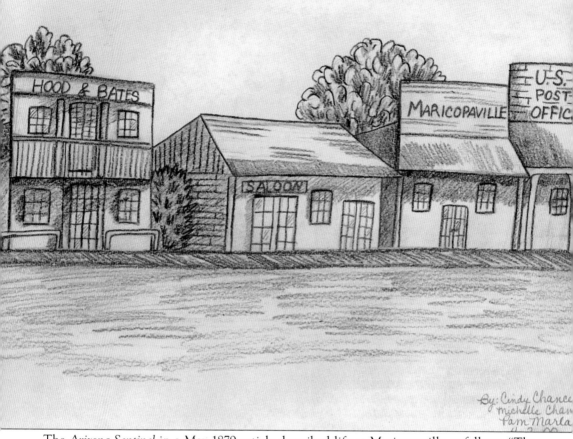

The *Arizona Sentinel* in a May 1879 article described life at Maricopaville as follows: "The Railroad Company has erected a fine warehouse surrounded by roomy platforms, and flanked by a two-storied building for offices, passenger rooms, etc. The latter is really a handsome edifice. The warehouse is full of freight, indicating a healthy demand for goods in the central part of Arizona; agricultural machinery and mining tools form a large proportion of this freight which is another healthy symptom. Klein, the Popular has his hotel running in full blast, and gives the same satisfaction he always did. Several other restaurants are in operation and a new hotel of two stories is nearly completed." It also predicted Maricopa's dry climate would further boost the economy by bringing in large populations of invalids who would require good hotels, supplies, and luxuries to meet their needs. (Drawing by Pam Marlar and Cindy and Michelle Chance.)

Three

MARICOPA JUNCTION
GOLDEN AGE OF THE IRON HORSE

The first train left Maricopa on its 35-mile journey through uninhabited desert terrain to connect Phoenix and the Salt River Valley with the Southern Pacific Railroad at Maricopa and the rest of the world on July 4, 1887. The coming of the railroad revolutionized the economy of Arizona. It brought merchandise into the state by rail instead of wagon and allowed local products to reach eastern and western markets more quickly. When the Maricopa and Phoenix Railroad (Arizona Eastern Railroad in 1910) made its maiden journey into the Salt River Valley, an estimated 7,000 people lived in all of Maricopa County, and railroad fever spread like wildfire throughout the area. Phoenix celebrated this momentous occasion with a fiesta that included brass bands, parades, picnics, and speeches about the great and prosperous days ahead. The festivities ended with fireworks.

For the next 60 years, throughout the state of Arizona, the train made a major impact upon people and was an important part of their lives. It became a source of faster and more comfortable travel and opened the entire West up for progress and development. Trains not only provided a new and exciting mode of transportation but also held a certain mystique that captured the imagination of the American people. They listened for the shrill whistle and sounds of the powerful locomotive as it thundered down the tracks and as it gradually slowed to accommodate its passengers and loads. It was a time when the iron horse ruled the day.

However, the M&P suffered difficulties from the very beginning. Floods frequently washed out the line, causing the trains to be a day to a week late. This stranded passengers in Maricopa while employees repaired lines and bridges. Therefore, Southern Pacific Railroad built a new line in 1926 from Picacho to Chandler and Phoenix and discontinued one passenger train in 1932. The second passenger train to Maricopa ended its services in 1933. Southern Pacific Railroad closed the Arizona Eastern Railroad to Maricopa completely by April 15, 1935, and a few years later tore up the tracks that ran from Maricopa to Phoenix.

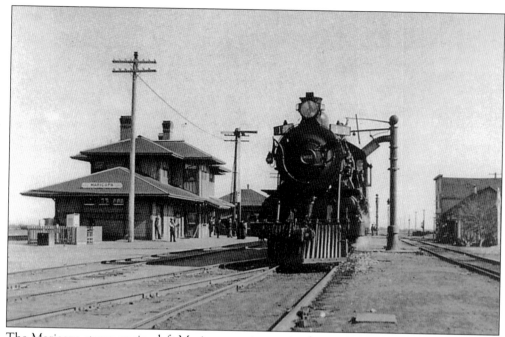

The Maricopa steam engine left Maricopa station on its first journey into Phoenix on July 4, 1887, and a large jubilant crowd had assembled at the railroad terminus to greet it. The entire Salt River Valley celebrated its arrival with parades, speeches, and fireworks. That evening, the train returned the 35 miles to Maricopa in reverse, as no turntable had been built yet.

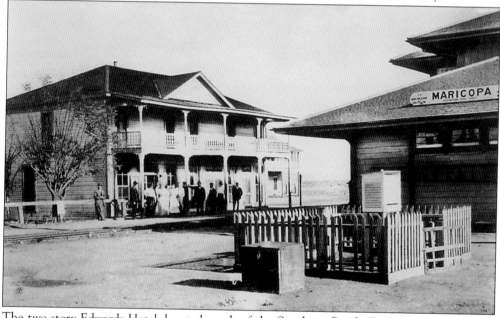

The two-story Edwards Hotel, located north of the Southern Pacific Railroad Station in the 1890s, had a lobby at the west end of the building, a restaurant in the middle, and a store on the east end of the hotel, and behind it was a small yard with a veranda. Mary Ellen Edwards tapped into the idea of sponsoring honeymoons, which proved to be lucrative, and the Edwards Hotel became a haven for honeymooners from the Salt River Valley in the early 1900s.

Several famous and some not so famous people stopped over at Maricopa on their way to the east, west, or into Phoenix. Two famous people included Pres. William McKinley and Pres. Theodore Roosevelt. Edna Edwards, the tall girl shown in the photograph and the daughter of Mary Ellen Edwards, received flowers from Ida McKinley, the wife of President McKinley. John L. Sullivan, who was considered one of the most popular and flamboyant champions in boxing history, was a guest at the hotel, too.

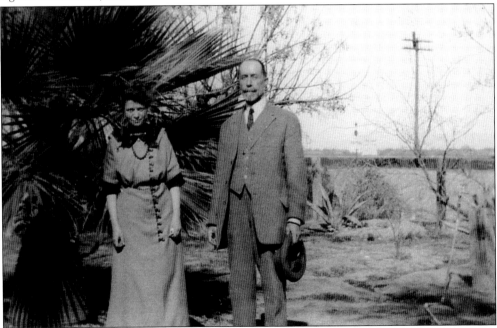

Perry Williams built a long rambling home southwest of the railroad tracks in 1884. On November 9, 1911, he married Clara E. Kelly in El Paso, Texas, and brought her to Maricopa. Clara became very involved in the Maricopa Women's Club and frequently traveled by train with other women into Tempe and Phoenix to join those women for luncheons and attend special events.

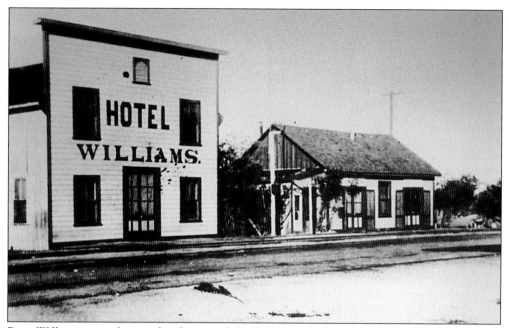

Perry Williams not only owned and operated the Williams Hotel south of the tracks but also served as the first mayor of Maricopa and its first justice of peace. Williams was an astute businessman and was politically well connected through his friendship with the first governor of Arizona, George W. P. Hunt. His movements were frequently noted in newspapers from Phoenix to Bisbee.

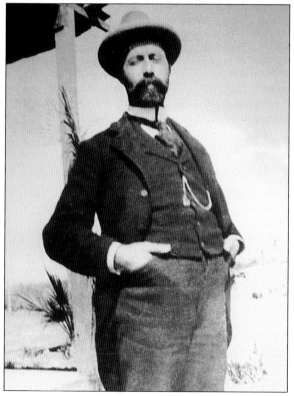

Cyrus Williams, brother of Perry, moved to Maricopa in 1887 to help with the hotel business. He greeted passenger trains with bells ringing and whistles blowing to drum up business. In 1896, he was closing the bar one night when a miner from Jerome came into the bar located in the back room of the hotel. The stranger wanted a drink; Cyrus wanted to go to bed. Without warning, the miner shot him. Perry drove him to a Tucson hospital, but Cyrus did not survive.

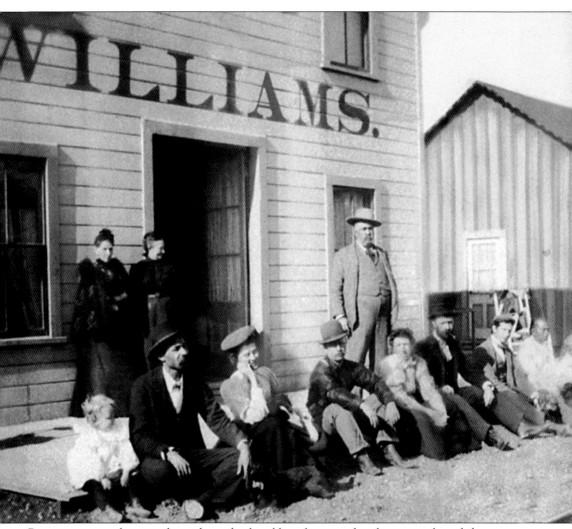

Passengers not only spent the night at this hotel but also visited with one another while waiting for their train. In April 1891, a young man from Blairstone, Missouri, W. E. Wilson, who was about 35 years old, came to Maricopa for another reason, his health. He had consumption, but the disease had progressed considerably, and not even Arizona's dry climate could save him. A special dispatch brought a message to the *Republican* newspaper from his grateful Missouri family that said, "He was a stranger in a strange land, yet found here brothers in Free Masonry, who did all that was possible to smooth his pathway to the grave. He was buried with all the honors of Masonry and now he sleeps under the shade of a mesquite tree in the beautiful Santa Cruz Valley." The family recognized and gave thanks to the many kind Maricopa people who helped their son during his last days.

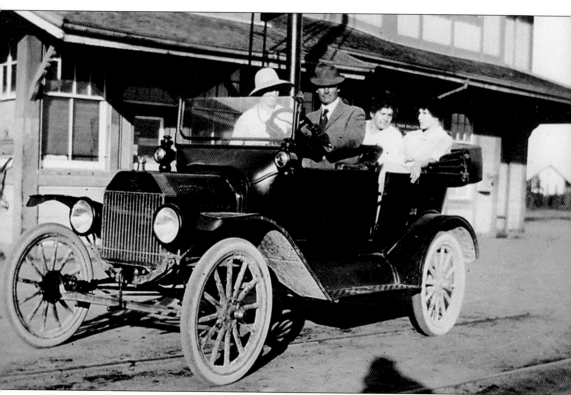

Several residents owned automobiles in Maricopa in the early 1900s. Dallas and Susie Smith, shown in the front seat, owned the one in the photograph. James McCarthy owned a Stoddard Dayton, which cost $3,000. Carl Hayden commandeered McCarthy's car in order to chase a couple of young bank robbers across the desert south of Maricopa in 1910. McCarthy and Williams were hotel competitors and enjoyed teasing one another. McCarthy suggested the profit at the Hotel Williams was not sufficient for him to afford the luxury of such a fine machine. This caused Williams to purchase an Overland from a car dealership in Phoenix. One day McCarthy's Stoddard happened to be on the blink, and Williams took advantage of this opportunity by cruising around McCarthy's hotel constantly blasting his horn.

The Hotel Williams, shown above, was south of the tracks, and the station was located between the tracks. The Maricopa Hotel was located north of tracks. According to early pioneer Paul Deal, railroad workers consisted of a section boss and section hands who kept the trains running safely. "Just as water and fire were necessary to a steam-powered engine, the track was under immense weight of a train, and changing defective rails and crossties was hard work," said Deal. The section boss was responsible for miles of tracks and supervised the work of others. The track-walker had the tedious and lonely job of going back and forth over miles and miles of rails, tagging areas that needed repair. His small rail-cart was hand-propelled with gears and wheels set in motion by pulling and pushing a ladder-like handle back and forth. One of the few restaurants in town, the Lunch Room, shown below, was located next to the Hotel Williams and was where passengers frequently passed the time by sitting and watching the trains load and unload.

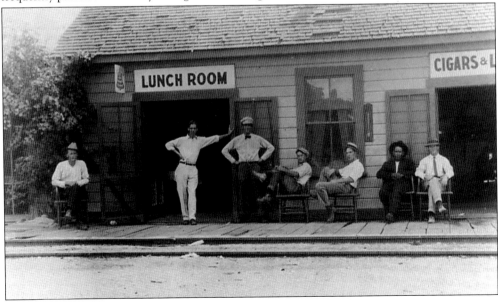

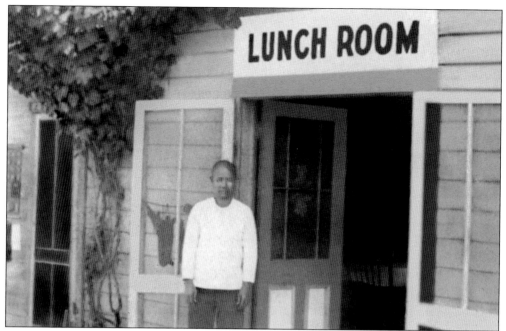

Sing Ching, one of the finest cooks in the territory, is taking a break in front of the Lunch Room restaurant. The proprietors of the Maricopa hotels and restaurants sought the best of everything for their establishments during its early days, and the importance of having a good cook was definitely recognized.

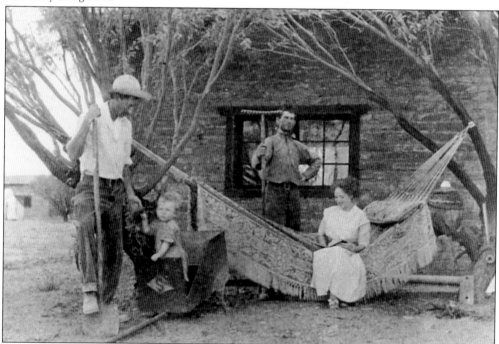

Earl Goodson, shown in 1911, owned and operated the Lunch Room in Maricopa. He and his family (unidentified) lived east of Maricopa. Most families had gardens, grew their own food, and frequently slept outside in the heat of the summer.

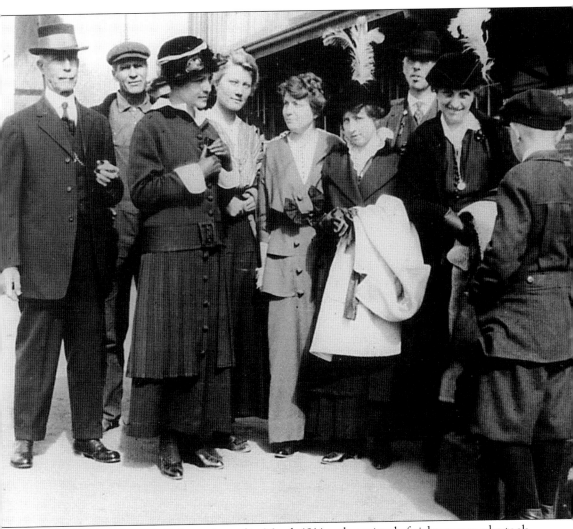

The Maricopa Women's Club was formed in March 1914 and consisted of eight women who took turns hosting meetings and "500" parties. However, the good times at Maricopa changed when a fire destroyed the Hotel Williams at the peak of its operation on April 29, 1913. It happened shortly before 3:00 in the morning. The fire burned not only the hotel but also the post office and several smaller buildings near it. The estimated damage was $25,000. The greatest loss was to the wildcats and Perry Williams's collection of Indian baskets. After Perry Williams left Maricopa, he built a large home on North Central Avenue in Phoenix. It was just north of Thomas Road and covered over a square block of land. He became a home builder and sold a great number of houses in this vicinity. Pictured from left to right are Perry Williams, ? Shreve, unidentified, Susie Smith, Clara Williams, and four unidentified.

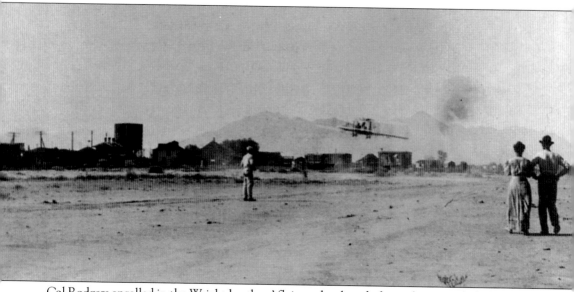

Cal Rodgers enrolled in the Wright brothers' flying school, and after only one and a half hours of instruction, he made his first solo. In 1911, William Randolph Hearst offered a prize of $50,000 to the person who completed the first transcontinental flight in the United States. Cal Rodgers, who was deaf, entered the race, financed by a new drink called Vin Fiz Grape Sodas. He took 931 cigars on his journey to satisfy his habit of smoking 19 cigars a day. After spending the night in Maricopa while the mechanic made repairs, he flew into Phoenix the next morning for a short exhibition. At the end of 49 days and a distance of 3,417 miles by rail, or 2,567 miles by air, Cal Rodgers completed the first transcontinental flight from New York to Long Beach, California, on December 10, 1911.

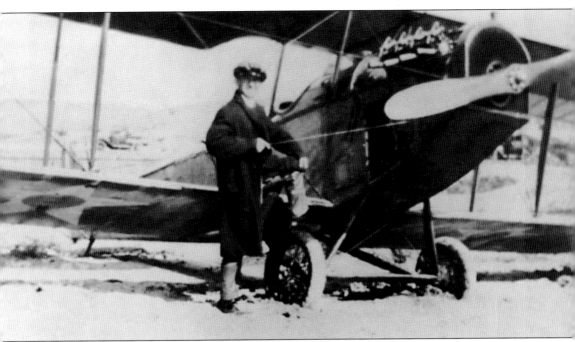

Maricopa resident Earl Goodson checks out a marvelous flying machine that landed in Maricopa. Cal Rodgers made his famous flight across country a few years earlier, and after many crashes, including one in the midst of a chicken coop and another when he was thrown from his plane, his aircraft landed in Maricopa. The engine was spurting oil, and while in Maricopa, he also discovered that four rollers on a chain were broken. Rodgers's train, "The Special," developed trouble, too. After a new locomotive arrived for the train, Rodgers allowed a stranded traveling circus to hitch up their boxcar.

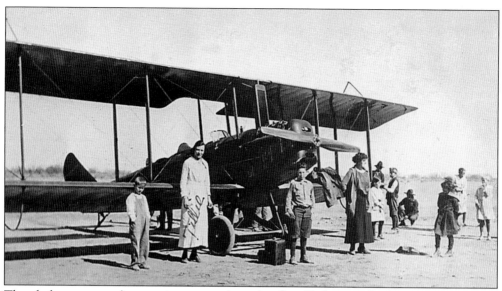

The whole town turned out to witness a machine that flew. Unfortunately, the owner of the plane is unknown. In 1911, Robert Fowler was also a competitor for the first transcontinental flight and was the second pilot to cross the continent, but the first to do so by flying west to east. Both pilots finished, and both landed in Maricopa. However, Fowler remained in the air over Maricopa for 40 minutes before landing, setting a briefly held sustained flight record.

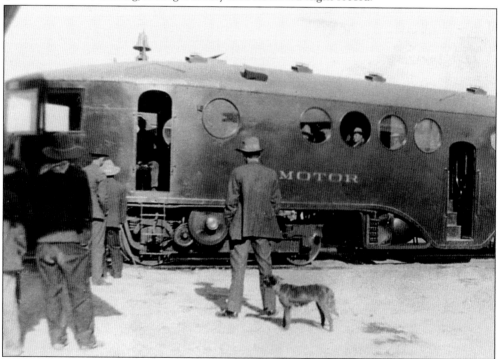

Besides trains, cars, and airplanes, Maricopa had the Doodlebug, a one-car train that ran between Maricopa and Phoenix in the early 1900s. It carried passengers, mail, and small freight. This train was a single electric diesel car with approximately 20 seats for passengers and room to carry baggage. In addition, the Doodlebug provided special excursions into the Phoenix area for local citizens.

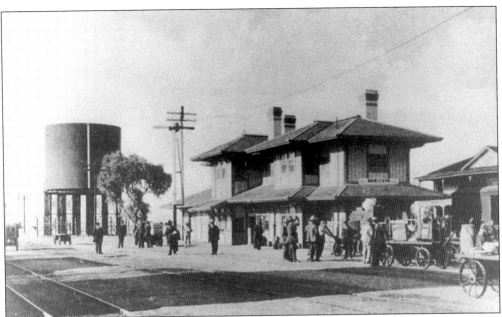

The atmosphere at the Maricopa station was peaceful and orderly most of the time. However, one of the biggest problems for the railroad was with non-revenue riders. Often referred to as "Knights of the Road," hobos became embroiled in a fight that involved stones, knives, and clubs in 1904. Local citizens and law officers broke up the fight and locked the unruly men in a boxcar to cool off. Before long, these quiet quarters became too much for them, and they set the boxcar on fire. They were lucky that someone saw the fire before it was too late to rescue them.

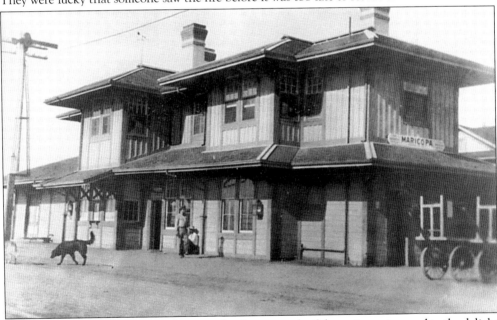

In the fall of 1907, four hobos broke into a freight car north of the train station, and to the delight of the aimless drifters, the car appeared to be loaded with barrels of whiskey. However, they did not read the labels when breaking into the barrels of wood alcohol—methanol—and the next morning, they were no more. Notice the many baggage carriers around the station.

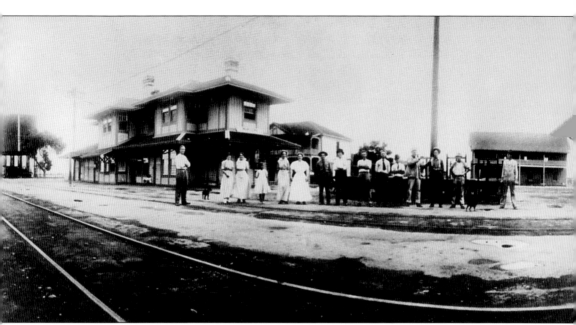

Law and order was swift in Arizona and Maricopa during the early train days. Robbing a train was an automatic hanging offense. "Maricopa Slim," also known as John Powers, Maricopa's law enforcement between 1910 and 1914, is standing in front of the telegraph pole. According to several local sources, the Southern Pacific Railroad hired him as a railroad detective, but some say he extended that authority to include the entire town. One incident involved two prisoners who had escaped from Florence, and a rumor had them headed for Maricopa to get John Powers, who had sent them to jail the previous year. Powers was aware of the escape and the possibility they were in the area. He was scouting the desert area outside of Maricopa searching for them when he came upon the pair cooking breakfast over a campfire. Powers shot and killed J. C. Miller and returned J. C. Wilson to jail in Florence.

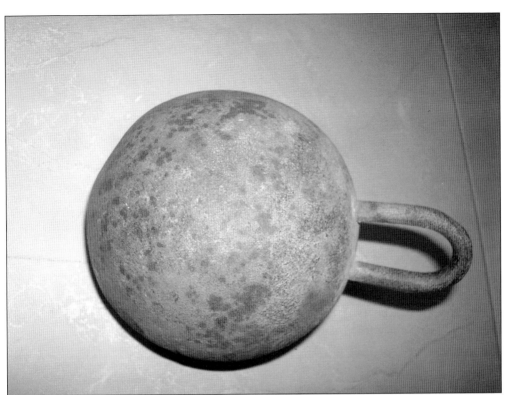

This ball is part of the ball and chain used by John Powers in 1910 to contain lawbreakers until taken to jail. The ball weighs 22 pounds, which is definitely heavy enough to slow a prisoner down. The billy club used by Powers had a lead-embedded center. A temporary makeshift jail constructed of railroad ties contained prisoners until they were moved to the county seat in Florence. About a year after a desert shoot out that left one man dead, Powers encountered another challenging situation. It appears there was a racial issue in progress on November 4, 1914, on a train just arriving at Maricopa. Powers was sent to settle the argument. Patrick Meehan, employed by the Barnes Circus, started to leave the train. Powers ordered him to raise his hands, but he allegedly made some sort of threatening motion, and Powers pulled his .45-calibre revolver and shot Meehan four times. Falling upon the ground, Patrick Meehan aimed his revolver and shot Powers in the abdomen. Both men allegedly died. (Both, Andy Cole.)

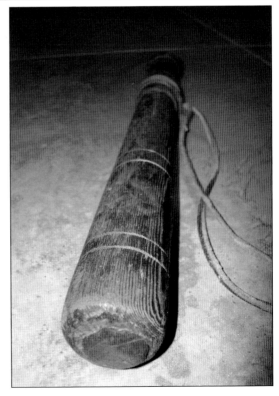

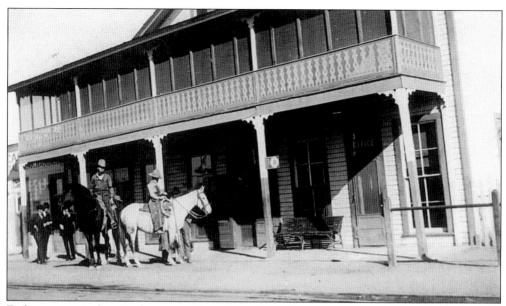

Early pioneer Arthur Deal came to Phoenix on New Year's morning in 1898 and was hired by W. J. Murphy at a time when there were only a few thousand people living in the whole Salt River Valley area. Also at this time, there was a tollgate at Central Avenue and McDowell Road that was the main entrance into the Murphy Empire. Murphy was so impressed with Arthur Deal that he offered to send him to college. Instead of perusing a college degree, Arthur Deal became a railroad engineer for the Arizona Eastern Railroad junction in Maricopa and bought the Maricopa Hotel. (Arthur Deal family.)

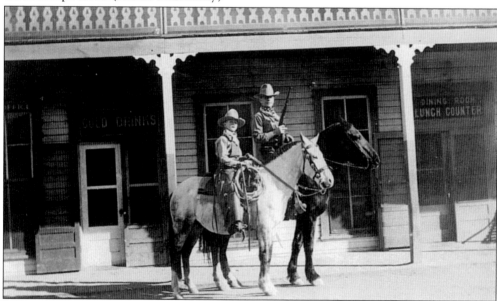

Arthur Deal owned and operated the Maricopa Hotel from about 1919 to 1931. The hotel had 23 rooms, a restaurant, a store, and a post office. There was also a one-pump gas station at the northwest corner of the property. It was here that Deal met many real estate and private promoters seeking large cheap acreage for speculation and promotion. The Maricopa Hotel burned one morning while Deal was at his homestead east of town. (Arthur Deal family.)

Dallas and Susie Smith were neighbors of the Arthur Deal family and were also early Maricopa pioneers between 1912 and 1956. They not only promoted the building of the school in Maricopa but also assisted with its construction in 1914. Over the years, they often had teachers rooming with them because of limited housing in Maricopa. Dallas Smith was one of the first school board members, served on the Maricopa Irrigation District, and was secretary of the Maricopa Power District No. 3.

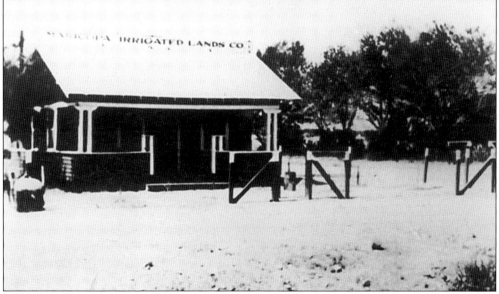

Arthur Deal bought and moved this irrigation and land building east of Maricopa and remodeled it for his homestead. He built a room on the back and a shed, put in a windmill, dug a garden, added chickens and cows, and planted fig trees. The desert area offered a variety of landscapes along with a considerable amount of wildlife, which included quail, cottontail and jackrabbits, coyotes, rattlesnakes, sidewinders, and an occasional horned toad or Gila monster. (Arthur Deal.)

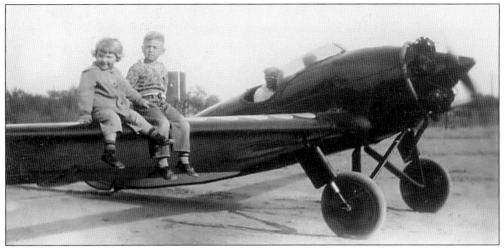

Paul Deal, the oldest son of Art and Ruth Deal, reminisced about the wonderful childhood he and his siblings had growing up in Maricopa with lots of freedom and space to roam. They rode their horses everywhere, ate tons of dust, and remembered that every wash was a threat to them and their family. One great adventure for five-year-old Paul and his three-year-old sister Marjorie was a ride in a monoplane with barnstormer Monty O'Tool in 1927. (Arthur Deal.)

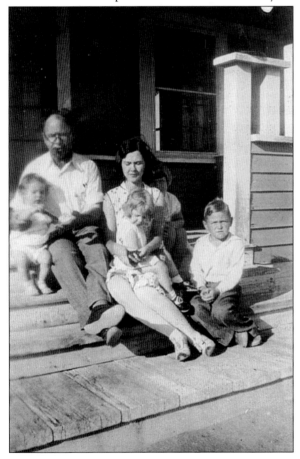

In this 1930 photograph, Arthur Deal is holding his youngest daughter, Joy. His oldest daughter, Ruby, is holding his first granddaughter, Beverly Deal Woods, and Marjorie and Paul Deal are on the front steps. Paul remembers, "I learned to work early in life, to build fences, cut wood, chop cotton and I was the chief cook at a neighboring ranch. I even made biscuits—no one died." (Arthur Deal.)

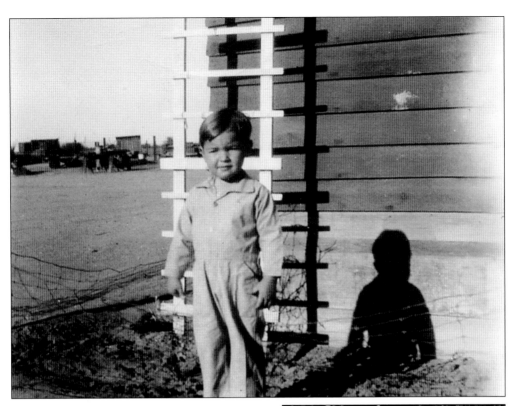

The youngest Deal, Tommy, is standing in front of the trellis at their home east of Maricopa. Marjorie Deal remembers, "In the summer, this trellis was full of flowering vines. Sweet peas, Queen's wreath, or some other type of flowering vine covered the fencing around the large garden, too." (Arthur Deal.)

Art Deal was a tree planter and planted the original ash trees down Central Avenue in Phoenix when he came from South Carolina and worked for W. J. Murphy Ranches. He planted trees around the Maricopa Hotel and later the schoolhouse when he was on the board of trustees. There was an abundance of trees around their homestead. Young Paul and Marjorie Deal are standing in front of a few of them. (Arthur Deal.)

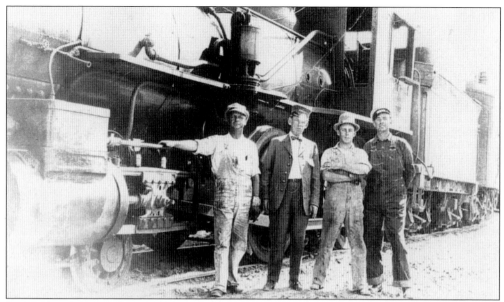

Railroad engineer Arthur Deal is standing on the left with unidentified railroad crew. Trains took on water at Maricopa and operated on steam for many years. Then diesel locomotives became popular, and by 1957, almost all locomotives operated on diesel. Southern Pacific had refrigerated cars in operation by 1886, which was an economic boon for citrus and other perishable fruits and vegetables hauled to market.

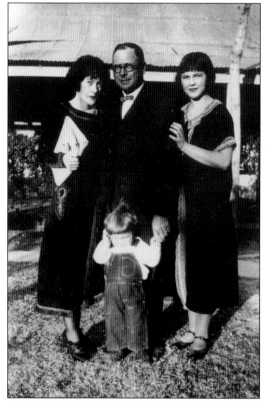

Ruby (left) and Helen (right), daughters of Arthur Deal, are standing on either side of Arthur with Paul in front. The family homestead had a library to house the many books that were so important to the Deal family, and when Ruth Deal became ill and bed-ridden, it was at this homestead that young Marjorie learned to cook on a wood stove and to keep house for her family. (Arthur Deal.)

Dallas Smith, standing at left, visits with Jack and Clara Burkett in 1936. When few people lived in Hidden Valley, Burkett had a ranch in that area. He always had a pot of coffee on for his Papago friends or anyone else who dropped by. Burkett did a lot of prospecting and knew the Estrella Mountains and the old rock house located there better than anybody. Paul Deal remembers exploring the area and Maricopa Wells many times with Jack during his childhood.

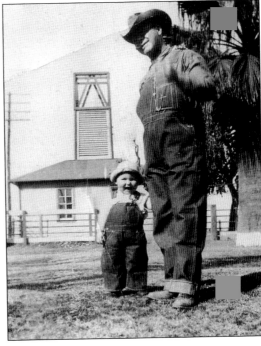

Arthur Deal and young Paul Deal take a few minutes to enjoy the day. Paul frequently accompanied his father around town. The palm tree continued to be a part of Maricopa for more than 80 years. (Arthur Deal.)

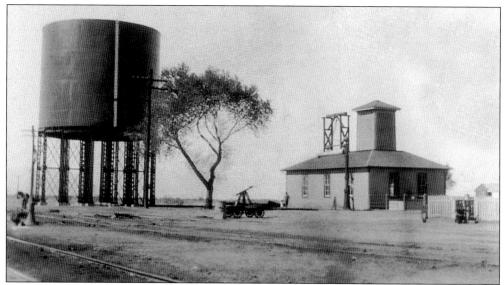

The railroad supplied water to the town with its 500,000-gallon water tower, and Electrical District No. 3 was in operation by the 1930s. In the early 1950s, the Southern Pacific Railroad sold the local water system to Silas Woods, proprietor of Woods Trailer Park, for $1. However, Woods was kicking himself for buying it after he had to buy a valve that cost $48. He sold it to Ed Farrell and Jay Baldock, who incorporated the Maricopa Water Works in 1955.

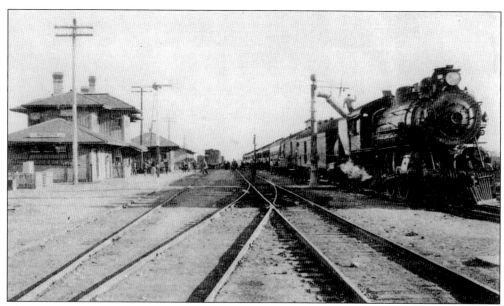

The main railroad station was a two-story building. The upper story was the living quarters for the agent, Dallas Smith, and his family. North of the station stood the two-story Maricopa Hotel. The railroad Express Building was east of the station, and east of it stood the freight house. It had a 350-foot-long ramp on each end and a runway on each side. Railroad workers unloaded cargo onto the platform and into the freight house until consignees picked it up. Farm machinery was unloaded and driven down the ramp at the opposite end.

Edgar Poe DeHart and his wife, Nina, moved to Maricopa in 1927 with their two sons, Robert (Bob) and Donald. The whole DeHart family had a great appreciation for music, but the real love for music came from the father, who played the guitar, violin, and mandolin. Both sons played the piano quite well. Pictured are an unidentified man and Edgar Poe DeHart (right).

When the DeHart family came to Maricopa, Donald was fascinated with the beautiful Arizona desert and sunsets. The two young DeHart boys played with their dogs and rode their bikes everywhere. There were no coolers or fans to help with the summer heat, but their mother ran the water hose into the screen porches and sat with her feet in the water to cool down during the hottest of times. Those pictured are, from left to right, Helen Smith, Robert DeHart, Donald DeHart, and Dorothy Smith.

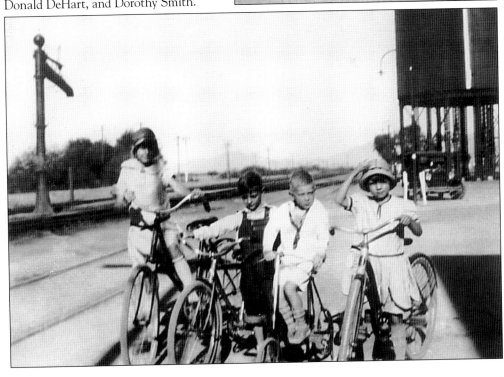

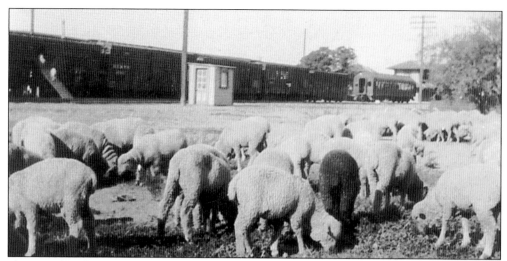

Sheep and livestock, including wild horses, were kept in corrals east of the station until sent to slaughterhouses. One of the round-ups included an Arabian stallion who was the leader of the group. The workers managed to load all the horses but not the leader, because he was smart and not easily fooled. They worked with him at least 40 minutes, trying to get him into the railroad car, but he fought them relentlessly. Finally, they were able to get him boarded. However, someone called the Phoenix buyers and told them about this beautiful horse, and he was rescued.

Donald DeHart recalled that rattlesnakes and scorpions were everywhere. Their mother ran her hands through their pants, shirts, shoes, and socks before allowing the boys to wear them. Frequently, they stepped out the door only to discover a large coiled snake next to the step. In this photograph, a Mr. Pruitt, the person in charge of the signals for the railroad, is holding the evidence of one encounter.

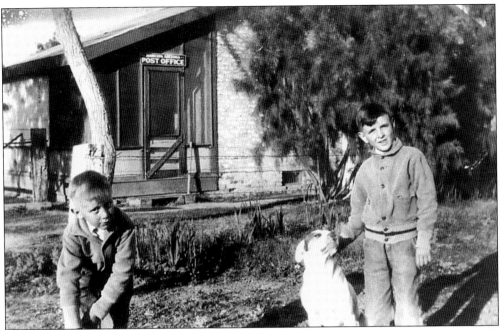

Jack, the DeHart dog, knew the train schedules and was always out waiting for them at the appropriate times. The boys wondered about this habit, but one day the reason became clear. The cooks loved him, too, and every time their train traveled to Maricopa, they threw off big chunks of meat to Jack. Those pictured are, from left to right, Robert DeHart, Jack, and Donald DeHart.

In the 1930s, a couple of men came to Maricopa and set up a woodcutting business. They contacted the people on the reservation and arranged with them to haul mesquite trees and limbs into Maricopa for cutting. This wood was sawed into pieces about 18 inches long for easy handling, and the DeHart boys got a job throwing wood into the cars. Here is Nina DeHart, with her mother, in front of stacked wood.

Edgar DeHart was the Maricopa postmaster, and the DeHart boys had the job of carrying mail sacks from the depot to the post office located in their home. The house was approximately 500 feet east of the railroad's freight building. It had two screen porches, one on the east side and one on the west side. There were two bedrooms, a living room, and a kitchen. Southern Pacific provided the family with 50 pounds of ice daily, which was kept in a wooden box on the porch. Here are, from left to right, Robert with his dog Friskie, dog Jack, and Donald DeHart.

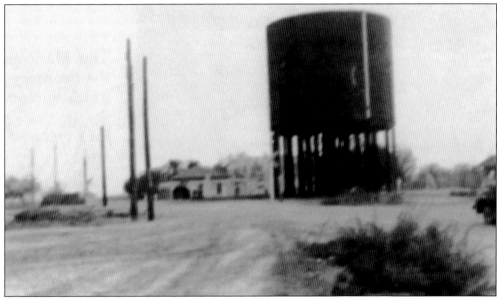

Fire destroyed almost all of the buildings in Maricopa early in 1931, and Jack Burkett built a second Maricopa Hotel southwest of the tracks in the same year. This Maricopa Hotel suffered the same fate in January 1954. Today the Red Business Barn stands in the same spot as the Maricopa Hotel.

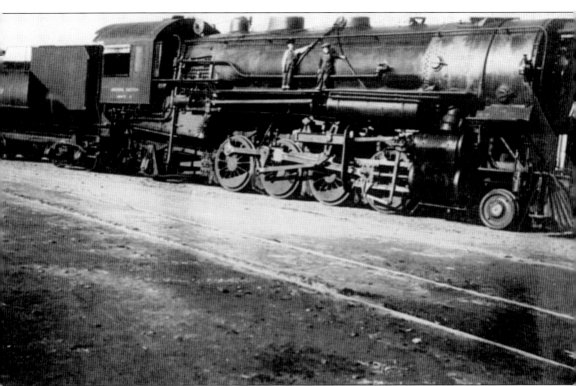

A dark cloud enveloped Maricopa and the nation in the 1930s. The DeHart family had $4,000 in savings at Phoenix Savings and Loan Company when all of the banks closed. Their money was lost, and three years later, they received a mantel clock to compensate for their loss. People all across the country lost their money and homes, and many became destitute. Donald DeHart said prior to the closing of the Savings and Loan Company, it was a common sight to see three or four un-cashed checks on the piano. Now, suddenly, they had lost everything. When the Depression hit, the railroad laid off many employees, including Edgar DeHart. Eventually he got a WPA job working on road crews. His duty was to shovel sand—in 115-degree weather—into a dump truck. He worked all day at this job and received $1 per day. The railroad let the family temporarily live in the company house without paying rent.

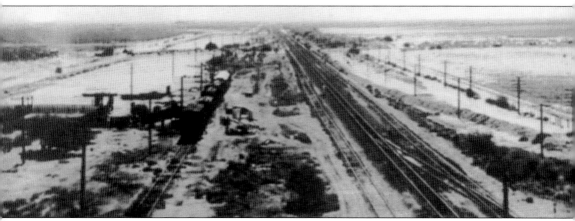

The DeHart boys climbed up this water tower and watched for the train that brought their dad home from work up north during the early days of the Depression. He recalled the many long trains of cars passing through and stopping at Maricopa, "These cars were covered from one end to the other with human beings. Men! Women! Children! Going anywhere and everywhere to find work! Open boxcars filled with people—some carrying their little dogs or cats—others carrying their few belongings." He recalled many of these people coming to their house asking for food or work, "They begged for just a piece of bread, and even in their desperate state, the homeless people were not mean or disrespectful if refused." The young DeHart boys watched their mother share what she had, saw the despair in her eyes, and felt her sense of hopelessness when she could not feed them all. (Oral History Project: Maricopa Historical Society.)

Four

AK-CHIN
ONE OF THE LARGEST
FARMING ENTERPRISES IN THE NATION

Ak-Chin community is in the heart of the Sonoran Desert and is located both east and west of John Wayne Parkway and south of the City of Maricopa. It is comprised of Pima and the Tohono O'Odham people who are descendants of the first Arizona farmers, the ancient Hohokam. Ak-Chin is an O'Odham word that means "mouth of the wash," which refers to a special type of farming that depends upon washes or seasonal plains created from rains.

Ak-Chin Reservation was created in May 1912, and its government was organized in December 1961. Its five-member tribal council is elected democratically each year, with staggering terms. In addition, it has its own newspaper called the *Ak-Chin Runner*, a preschool, police and fire departments, ambulance service, parks, new homes for its people, a senior citizens program, health facilities, and the first of its kind, an eco-museum. These community facilities and programs reflect the values of its people, whose goals are to be self-governed and self-sufficient and to honor and celebrate the heritage and culture of the people.

Ak-Chin is a small, close-knit community comprised of about 770 tribal members living on approximately 22,000 acres of reservation. At one time, it struggled to survive by chopping and selling firewood to customers and eked out a living through farming with limited water. Then Ak-Chin Farms Enterprise, established in 1961, served as the main source of income for its members for many decades. One member, Richard Carlyle, was instrumental in getting the farms established, and his brother Herbert "Buddy" provided the foundation for securing its water rights. Today, with approximately 16,000 acres, Ak-Chin Farms is one of the largest farming enterprises in the United States.

Ak-Chin community expanded its industrial enterprises in 1994 to include the gaming industry with Promus/Harrah's management for a 72,000-square-foot casino. This casino includes a resort hotel and bingo facility that employs over 830 people, making it one of the top employers in Pinal County. In 2010, they purchased the Southern Dunes Golf Club and are also in the process of making a $22-million expansion to Harrah's Hotel.

During the early Maricopa Junction days, 92-year-old entrepreneur Wasnauk walked to Maricopa every afternoon from the Ak-Chin community with tools in hand to greet the passengers of trains No. 7 and 8. His tools were the bow and arrow, and his trade was shooting the hat off of anyone willing to take a chance. Many took the chance, and he never missed his target. Wasnauk was paid a quarter for this demonstration.

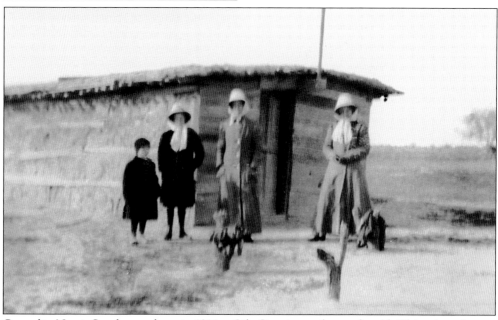

Carmelita Norris Stanley was born in 1914 at Gila Crossing and moved to Ak-Chin when she was four years old. She attended school in a small one-room adobe house that was the Presbyterian church. When she was 11 years old, her family sent her to boarding school at St. Johns. After this, she only returned home during school vacation. Here is the one-room house that was used as a school. The ladies in the photograph are unidentified.

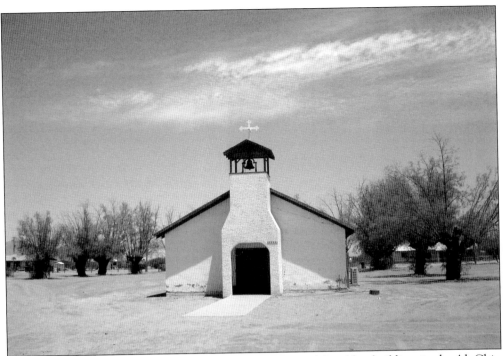

The St. Francis of Assisi Church, built in the 1920s, is one of the oldest buildings in the Ak-Chin community that has been in continual use since it was built. Community members used adobe and saguaro ribs to build the church. The murals on the north wall are originals painted in the 1940s by Jimmy Stephens from San Carlos Indian Reservation. St Francis Mission School, administered by Fr. Antoine Willenbrink, opened its doors for 20 students in 1926. Classes were held in the church, and Isabel Kisto, a Pima from Bapchule, served as the teacher. Southwest of the church is the Community Feast House, below, which was used for cooking and serving meals during religious ceremonies and community events.

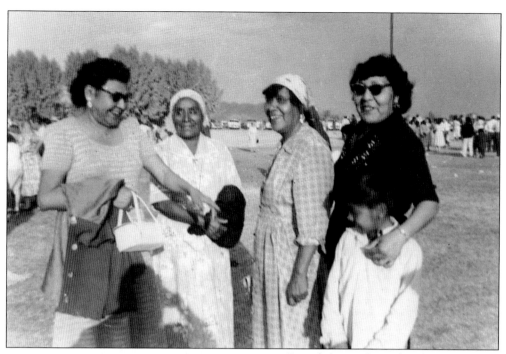

From left to right in the photograph above are Carmelita Norris Stanley, Antonia ?, Cynthia Manuel, and Mary Nez enjoying a day at the St. John's Bazaar in 1957. According to Carmelita Stanley, "One of the greatest improvements in the past 50 years for Ak-Chin community is farming and housing. Farming has expanded greatly at Ak-Chin, and there is much better housing for the families." (Leona Carlyle Kakar.)

Julieanna (Nancy) Antone Narcia, pictured at left, was the daughter of Perry Williams and Susie Narcia. Perry Williams moved to Maricopa in 1884, and Julieanna was born in 1888. Julieanna was the mother of Hiram John Carlyle and grandmother of Richard, Buddy, Leona, and Joanne Carlyle. Her family knew her as Nancy Narcia.

Hiram Carlyle attended Maricopa School and graduated from Phoenix Indian School in 1929 before serving in the National Guard in the 1930s. According to daughter Leona, "My dad was very adamant about all of his children getting at least a high school diploma but wished for more." Through their example of hard work, dedication, and perseverance, Hiram and Tillie Carlyle instilled in their children a sense of confidence, commitment, and leadership. Here is Hiram Carlyle at Phoenix Indian School in 1929.

Tillie Pablo Carlyle was born in Gila Bend in 1912 and moved to Maricopa when she married Hiram Carlyle in 1931. Tillie's family was made up of early pioneers of the Gila Bend area, and her husband's father, Hiram Carlyle Sr., worked at Maricopa Wells in the late 1800s. Tillie also had many relatives who lived in Gaka on the Tohono O'Odham Reservation, located south of Maricopa. (Leona Carlyle Kakar.)

Tillie Pablo Carlyle attended the boarding school in Sacaton and later the Sherman Institute in Santa Ana, California. During the summer, she lived with a family in California by the name of Rogers, babysat for them, and learned to cook. This opened up a new and different world for her, and it was an interesting time and learning experience. Then her mother, Johfthita Pablo, became ill, and she returned home to Arizona, where she met and married Hiram Carlyle. Tillie loved to cook and could make something great out of almost anything. She never measured anything, and it always tasted good. She had other talents, too. She was a master seamstress and made all of her children's clothing. She never used patterns or pins. She visualized how she wanted it to look, laid out the material on the bed, and began to cut. She was a carpenter, as well, and built her own closet, tables, and furniture. Here is Tillie Carlyle babysitting in 1931.

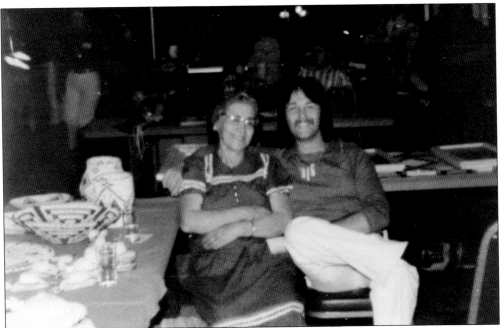

Tillie had many talents, but one of her greatest gifts was the beautiful baskets she made and took to special annual showings in Las Vegas. She worked all year on these baskets. This heavily advertised event brought in many buyers, and the baskets sold quickly. Here is Tillie Carlyle and an unidentified friend in Las Vegas.

Tillie Carlyle was quite cultured and interested in most things. She enjoyed going to hear the elders sing songs and visit with one another. They held these song sessions after dark and in the wintertime. They sang songs all night but stopped before sunrise. They knew how much this meant to her and always invited her to go. Leona, her daughter, remembered hearing her sing these songs often at home. She sang when she cooked and she sang when she sewed. (Leona Carlyle Kakar.)

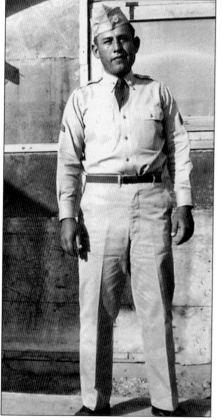

Tillie Carlyle not only appreciated Arizona's marvelous creations but also enjoyed football and politics—and was well educated in both. Her favorite football teams were the Washington Redskins and the Los Angeles Rams but definitely not the Cowboys! She stayed up all night during elections and had all of the statistics ready to share with the family over breakfast. Her two favorite presidents were Franklin D. Roosevelt and John F. Kennedy. She mourned Kennedy's death as if he were part of her family. (Leona Carlyle Kakar.)

Three generations and several members of the Carlyle family have served and continue to serve on the Ak-Chin Tribal Council. All of the Carlyle children have contributed toward completing the community's goal of creating an independent and self-sufficient farm. Despite Bureau of Indian Affairs (BIA) resistance, Richard Carlyle commenced the first major farming operation at Ak-Chin, called Ak-Chin Farms. Wilbert "Buddy," his brother, led the fight to obtain water rights for the tribe. Both Richard (33) and Buddy (47) died very young. Richard Carlyle is shown in his uniform.

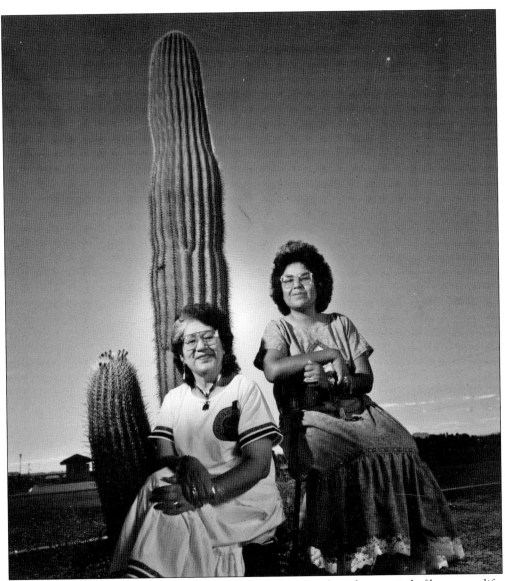

Leona Carlyle Kakar was born and raised at Ak-Chin except for a short period of her young life. Her family moved to Casa Grande in 1947, where Richard, her older brother, went to high school, and Buddy and Leona Carlyle attended an elementary school that was located on the extreme south side of town on the Chui Chui Road. She remembers: "Buddy did fine, but I was in shock coming from a one-room school with 25 students to a school with over 400 students. I got very sick and ended up in the Sacaton Indian Hospital for about a week. I had a fever and could not keep anything in my stomach at all. My Mama and Dad tried to help me adjust to going to the school, and Buddy told me where I was to go, and helped me to get myself enrolled in the 'Big School.' I was still sick the first few weeks, after I finally did start in the sixth grade. I failed all of my classes because I was so scared and unsure of myself. I never talked to anyone and was scared of all the many teachers I had to deal with every school day. I can't remember how I got over my fear of the 'Big School.' But, I did at sometime, because by the time I graduated from the eighth grade, with a class of 97 students, I placed either second or third in the top five students." Pictured above are Leona Carlyle Kakar (left) and niece Delia Carlyle.

After his sons were out of school, Hiram Carlyle decided it was time to retire as a diesel Caterpillar tractor mechanic. Later Leona Carlyle found out from those who worked with her father that his work was superior, and he was very much in demand. However, he wanted to come home to Ak-Chin and farm before he died. She said, "That was what he told me . . . I laughed at him because he was only 43 years old. I begged to go home with him, and he let me drop out of school." Hiram Carlyle went home at Ak-Chin to farm. "My Dad really enjoyed the four years from retirement to his death at 47 years old on January 12, 1958. I guess he knew when to retire after all." The youngest child of Hiram and Tillie, Joann, graduated from Maricopa High School and Arizona State University. She was a caring and dedicated teacher for more than 25 years in Maricopa. (Leona Carlyle Kakar.)

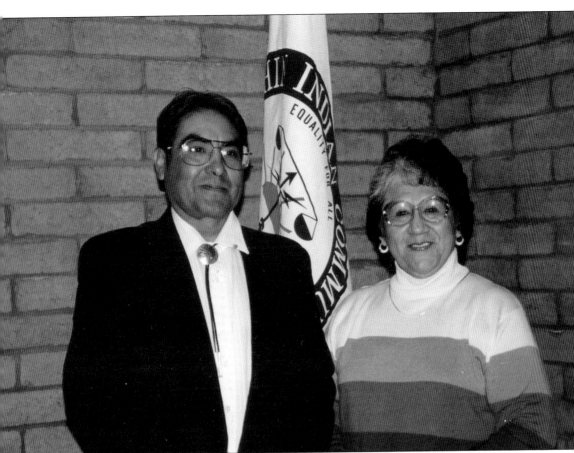

Leona Carlyle Kakar became the voice of the Ak-Chin community after her brothers died. She worked for many years as a dedicated leader and spokesperson. She became chairperson of the Ak-Chin Farm Board in 1965 and watched the farm grow from a 4,000-acre enterprise to its current 16,000 acres with a $10-million annual operating budget. Leona played an important role in the opening of Harrah's Ak-Chin Casino in 1994, too. She represented the community on many boards over the years, including the Maricopa School Governing Board, Southwest Indian Agriculture Association Board, and the Western Pinal Chamber of Commerce. She has received several awards, including one from the Heard Museum that honored her as Woman of the Year for her many contributions to the community and her people. At the 1999 Native American Recognition Days Awards, she received the Outstanding American Indian Leader Award for her leadership and contributions that made such a positive and lasting affect upon Ak-Chin and the American Indian people. Here is Leona Carlyle Kakar and Ak-Chin Tribal Council member Martin Antone Sr.

Juanita Norris volunteered wherever needed in Ak-Chin and Maricopa. She was one of the first to respond to the homeless families in Maricopa when the flood hit in 1983. During the school carnival festivities, she quietly went about organizing the popular fry bread booth that made the carnival so special. She repeated this ritual every year for decades. Her booth was always the one with the long waiting line. Those pictured above are, from left to right, Juanita Norris, Juan Anton Norris, and Mike Smith in 1955.

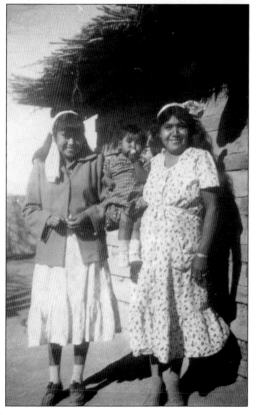

In the early days of Maricopa, Juanita recalls, "Maricopa's population was very small and life was on a day-to-day basis, with no worry about inflation or lack of transportation. The struggle of making a living today [1982, the date of the oral history interview] is more difficult than in the past. I miss planting my own crops and harvesting them. I miss the use of the wagon and buckboard, and being able to grind corn on an old-fashioned grinder. I miss the fashions and picking berries." Those pictured are Lucy Mike and Juanita Mike Norris holding her first grandchild outside her home in 1927.

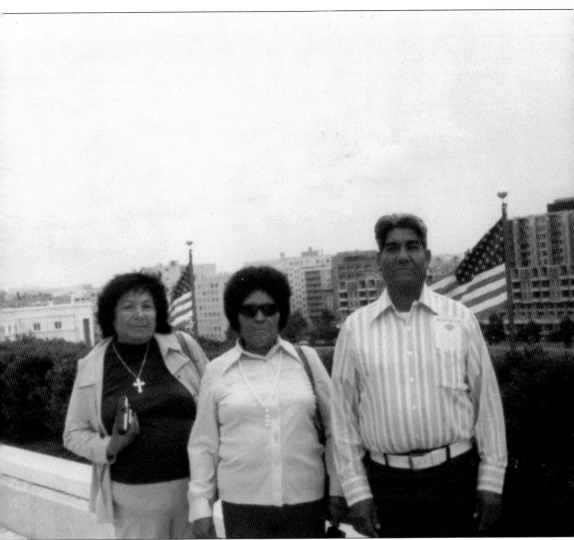

Patricia Smith, daughter of Juan and Maria Raphael, was born at Ak-Chin in 1915 and sent to boarding school in Tucson at the age of 14. Later, she married Michael Smith, who was also from Ak-Chin. According to Elaine Peters, the director of Ak-Chin Him-Dak Eco-Museum, "Her work will never be forgotten, and her love to serve her people, never asking for much, has earned her the respect and recognition for her place in the Women's Plaza of Honor." Patricia Smith became the first vice-chairperson elected to the Ak-Chin Tribal Council and served from 1962 to 1972. Over the years, she used her own vehicle to transport community members to the hospital in Sacaton and Phoenix and became the ambulance driver on call 24 hours a day, 7 days a week. When parents could not go, she became the person trusted to transport ill children to the hospital and back home, with detailed instructions on how to care for them. She also took them to nearby towns to purchase clothing, school supplies, and groceries throughout the years. She worked for the Ak-Chin Police Department from 1977 to 1987 and willingly served on every board and event that needed her. In addition, she was an avid photographer and an Ak-Chin historian who recorded many events within the community, ranging from baptisms to tribal feast events. Standing on the balcony of Kennedy Center in Washington, D.C., are, from left to right, Vera Antone, Patricia Smith, and Jonas Miguel.

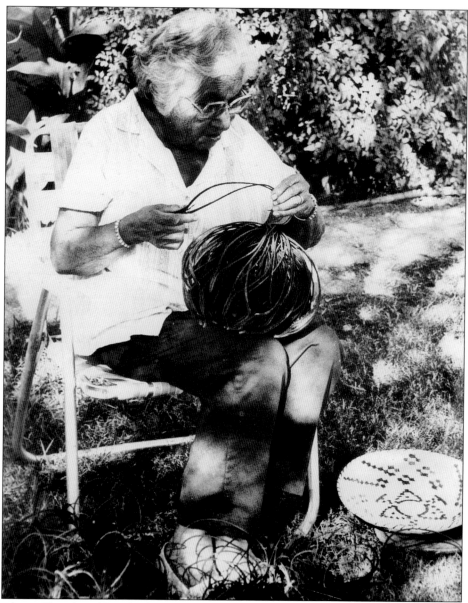

Daughter of Joseph and Josepha (Lopez) Thomas, Lena Lopez Thomas Enos was born in December 1917 in Ak-Chin. As a young girl, she attended elementary school at Ak-Chin and Sacaton and graduated from Phoenix Indian High School in 1935. In 1939, she married Ted Enos, who was a member of the Salt River Pima-Maricopa Indian Community. Lena Enos and Patricia Smith were the first women to serve on the first tribal council that was elected by the tribe, and they served for many years. Lena graduated from Arizona State University in 1974 and taught at Maricopa Elementary School for many years. She remembers riding on the train to school in Phoenix when she was young. She said, "The most important happenings in my lifetime was when the Ak-Chin tribe started their farming enterprise, which is now self-supporting, and the building of Maricopa High School." Her husband, Ted Enos, served as the first police officer for the Ak-Chin community in 1960 and became chief of the Ak-Chin Police Department in 1983. Lena Enos is making a brindle out of devil's claw (above).

Him-Dak, meaning "way of life," celebrated its opening on June 29, 1991. It is a community-based museum that links the collective memories of the past with the present as a strategy to drive future needs and reflect what is important to the community. Preserving Ak-Chin's heritage is important to the community, and today the museum houses and preserves more than 700 boxes of prehistoric local artifacts. This museum, headed by director Elaine Peters, is the first of its kind in America and welcomes visitors to come and learn about the heritage and culture of its people.

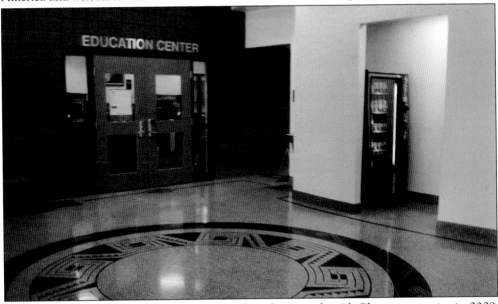

The state-of-the-art education center opened its doors to the Ak-Chin community in 2009. According to Jana Narcia, the education director, the community is taking advantage of the wide variety of programs within its department, and the center will continue to address the needs of the community in order to assist them in their educational pursuits. Melanie Tolado, the library manager, estimates more than 20,000 library patrons passed through its doors during the first year of operation and expects twice that number in 2010.

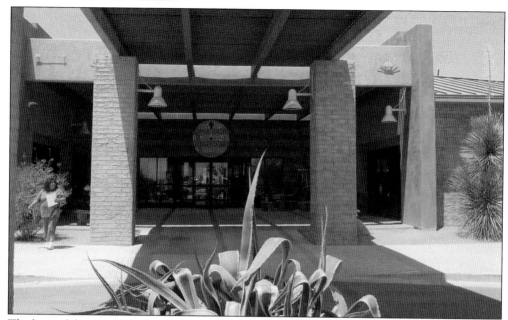

The beautiful community center shown above serves as a meeting place for the Ak-Chin people. In June 2010, Harrah's Ak-Chin Hotel and Casino held a ground-breaking for a 152-room expansion to its current hotel, shown below, that will provide space needed to accommodate the many customers who are turned away each night for lack of rooms. The resort hotel expansion will include many upgrades that incorporate the community's culture and a 75-foot illuminated tower that blends modern design with Native American elements. Members of the Ak-Chin Tribal Council are, from left to right, Gabriel Lopez, Anthony Narcia, William J. Antone, Leslie Carlyle-Burnett, and Louis Manuel Jr.

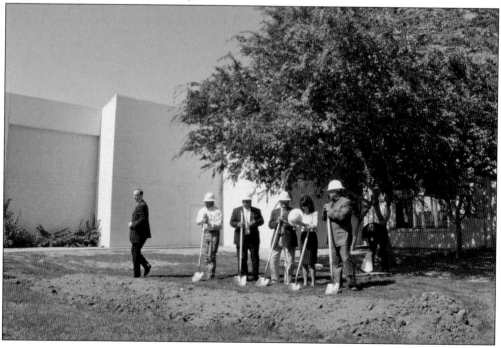

Five

FARMING
COTTON CAPITAL AND
CATTLE COUNTRY

At one time, the Maricopa-Stanfield area had one of the highest average cotton yields of any large area in the world. Its farming enterprises at its present location date back to the beginning of the 1900s. One of the first farms at Maricopa's present location was 5 miles south of town, on the corner of Maricopa and Papago Roads. Samuel G. Scott bought the farm the same year Arizona became a state, and by the end of the year, crops were already growing in the fields near his home. However, after the closing of the railroad, the slowing down effects of the Depression, and with much of Maricopa's land in litigation, there were little income-producing activities in Maricopa from 1930 to the 1940s.

After World War II, Maricopa's land was out of litigation, and it sold quickly to farmers who had moved into the area. There were about 100,000 acres of land cultivated and growing cotton by 1980s in the Maricopa-Stanfield area. Cotton was king! Hundreds of farm workers from the Midwest, other parts of the United States, and Mexico poured into Maricopa during the cotton-picking season. Maricopa's schools swelled, streets were crowded, and stores and restaurants were booming with business. Farmers experimented with a variety of crops in addition to cotton, including melons, lettuce, maize, wheat, alfalfa, barley, grapes, pecans, and pistachio trees. The soil was ideal for growing peas, too, but the market was not, and they were only grown one year.

The cattle industry moved into Maricopa in 1964 and 1965 with several feeding lots that eventually housed more than 200,000 head of cattle in the Maricopa-Stanfield region, making it the biggest cattle feeding area in Arizona. Several dairies moved into the area, too, including the Hogenes Dairy, located west of Maricopa on Garvey Road.

However, the farming industry lost its momentum when the water level could no longer support it. Farmers began to sell their lands to developers, and thus began a new chapter in the illustrious history of Maricopa.

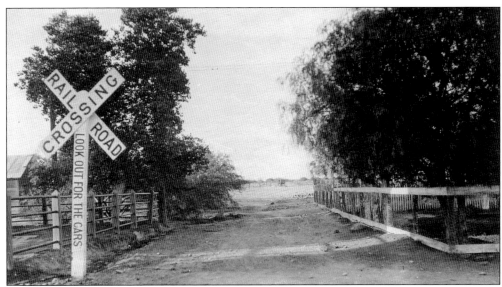

Travelers approaching Maricopa from the south in 1913 entered the town at this point. South of Maricopa was the Ak-Chin community, the Samuel G. Scott farm on Papago Road, and the White and Parker ranches southeast of Maricopa on White and Parker Roads. Summerland was located southeast of Louis Johnson Road on White and Parker Roads. This area, called Summerland, consisted of a small school and post office in the early 1900s. (Eddie Pratt.)

Today Eddie Pratt owns and operates the old Scott farm. Scott bought the land for $80 from Chas E. Arnold in 1912 and moved his family to the area in 1913. The farm was cultivated with a team of mules and a disc harrow. A variety of crops were grown with success during this period of time, including sugar beets, onions, corn, watermelons, cantaloupes, casaba, honeydew, and alfalfa. Yellow-globed onions were also very productive. (Eddie Pratt.)

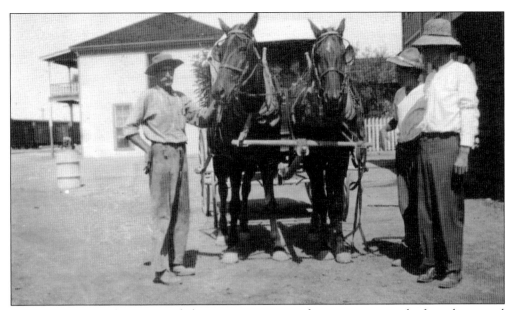

Three generations of Scotts traveled into Maricopa to purchase necessary staples from the general store at the Maricopa Hotel. Those pictured are, from left to right, grandfather Giffin, his son Samuel, and grandsons William Gilbert and Harold Martin (right). (Eddie Pratt.)

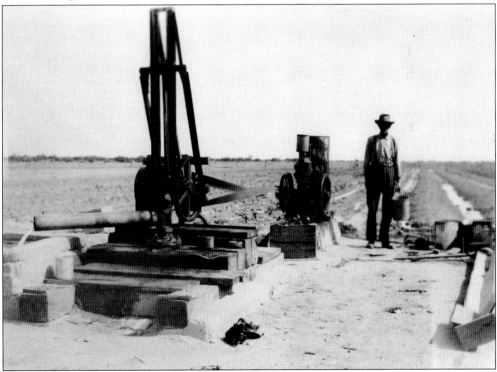

This is the first well at the Scott farm with grandpa Giffin (right) checking the crops and water supply. The Scott family dug two wells during the time they farmed the land. The first well was hand-dug and shoveled to a depth of 55 feet. A gas engine and belt-driven jack pump was installed, delivering 4 inches of water. (Eddie Pratt.)

Grandpa Giffin irrigated and attended his garden daily. A fence protected the garden from the abundance of hungry rabbits and wild mustangs that roamed freely in the desert. (Eddie Pratt.)

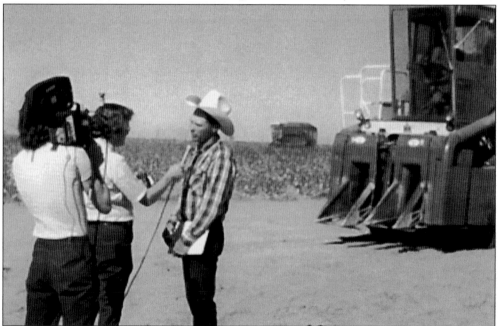

Eddie Pratt explains to the press how farmers from all over the area brought their machinery and harvested the crops of a cancer-stricken neighbor—in one day. Maricopa people were quick to help one another and share whatever they had. They harvested all of their sick neighbor's crops before tackling their own fields and crops. The women prepared food for all of the workers, ran errands, and assisted however and wherever needed.

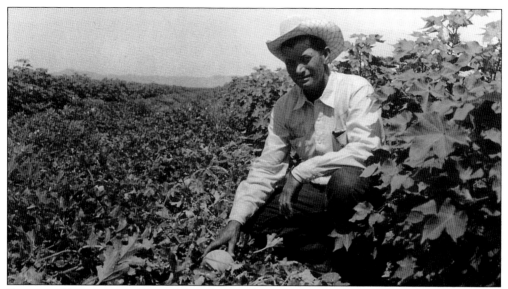

Farmer and businessman Edward Farrell not only grew cotton and grains but also experimented with a variety of other crops, including melons. Melons were loaded onto railroad cars and shipped to market via trains. In addition to melons, farmers planted pecan and pistachio trees and grew lettuce, maize, wheat, alfalfa, barley, and grapes, but cotton was king. In the beginning, cotton was handpicked, and contractors supplied the workers. Later cotton was machine picked and hauled to one of the 14 gins in cotton trailers.

Farmers frequently started their day by dropping in at the Dunn farm for a cup of Dode Dunn's "Forever Brewing Pot of Coffee" on the back burner. During World War II, Dode worked at the Florence Prisoner of War Camp as a telephone operator at a time when it was a manual switchboard. Both Sonny and Dode knew what it was like to be poor. During the Depression, Dode's family lived in one tent outside the town of Florence. However, according to daughter Shirley Dunn Kelly, her father's family had it a little better. They had two tents. Pictured standing from left to right are children Bobbie, Shirley Marie, and Bill Dunn. Seated are Dode and Sonny Dunn. (Sonny Dunn.)

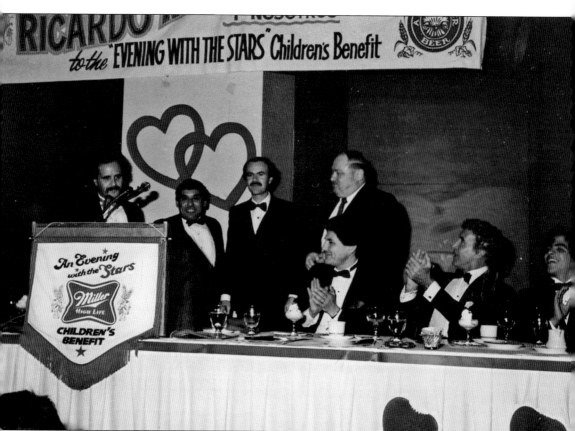

Milo Cano and his migrant family moved to Maricopa, Arizona, in 1952, when his dad got a job working for a farmer who crashed his airplane on his farm within a few feet of him. "We made eye contact with one another before he hit the ground." Milo remembers the hardships that followed that plane crash: the death of his father from an accident on the farm; his mother who grieved herself to death soon after; and how he and his sisters were homeless and orphans but survived with the help of the kind and generous people of Maricopa. His is a story of hard work and perseverance that eventually took him out of the cotton fields and into sales and finally to being one of the top Hispanic businessmen in the state of Arizona, who worked beside such notable figures as Eddie Bashas, Rose Mofford Bruce Babbitt, and others. In addition, he was very active with charity drives such as "Evening with the Stars" with Ricardo Montalban of Fantasy Island and other stars and dignitaries that benefited children in Monterey, Mexico. (Oral History Interview: Milo Cano family.)

Juan and Leonides Sanchez immigrated to the United States from Mexico in 1924 seeking a better way of life for their family. The family moved to Stanfield in 1940 and cultivated the barren Stanfield desert into farmland growing cotton for investors. The group of investors bought land in Maricopa and moved the Sanchez family to Maricopa. Later they sold it to John Peters and Chester Nall, who hired Juan Sanchez to help with farming cotton and other crops for more than 15 years. The oldest son, Tony, remembers, "My dad and I worked long hours and seven days a week on the farm." The other children remember they hardly ever saw their father during this time. However, according to daughter Trini, they were not lacking in parental guidance. She recalls their mother as being a strong female role model and quite strict. She organized daily schedules, and everyone worked. (Juan Sanchez.)

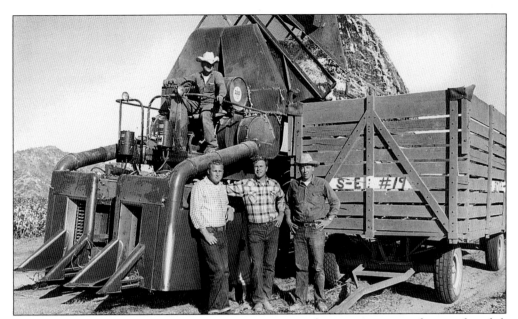

Standing next to the International Harvester experimental two-row cotton picker are, from left to right, Marvin Scott, Fred Enke, and John Smith. Atop the machine is Shorty Lawson. John Smith's grandfather was a U.S. marshal, and his grandmother was a Native American from the Kiowa Nation in Oklahoma. Smith's family came to Arizona in a Ford Model T at a time when there were no paved roads. The trip took 10 days. The family put down stakes in the religious settlement of Glendale, which is where John and his siblings grew up. The town had 38 churches and, like the town of Vekol in the 1800s, no bars. (Oral History Project.)

John Smith, with his young son Jack, is seen here discussing the farming business with his farming partner Fred Enke. Smith and Enke were star football players in the 1940s and 1950s, often referred to as the famous passing and receiving duo at the University of Arizona. Smith played professional football with the Los Angeles Rams for a while, but because of several injuries, he opted out to finish college. He eventually formed a farming partnership with Enke in Maricopa. Smith farmed the land, and Enke continued to play professional football with the Detroit Lions, Baltimore Colts, and Philadelphia Eagles. (Oral History Project.)

C. P. Honeycutt moved to Maricopa during its early farming years and was a successful farmer for many years. However, farming was not his first love. His first love was cutting horse events (separating a cow from a herd of cattle for a short time), and he became involved with this business the second half of his life. He was Arizona State Cutting Horse Champion eight times and won many trophies over the years. However, the high point in his career came when he was inducted into the National Cutting Horse Hall of Fame, held in the Will Rogers Coliseum in Fort Worth, Texas, in 1986, which is pictured above. C. P. Honeycutt was a friend to many celebrities, including John Wayne and Roy Rogers, and entertained many of them in his Maricopa home, shown below.

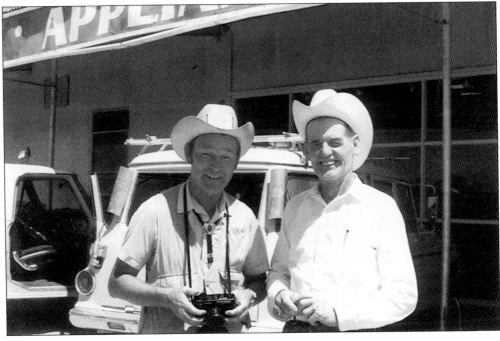

Dr. Phillip Hartman is shown with his two grandsons, Dale and Bryan, in a one-horse cart on the Hartman farm east of Maricopa. Part of the farm, which is still in operation today, dates back to 1875. McD Hartman, son of Dr. Hartman, owns and operates Hartman Farms today. His paternal grandfather, Rev. John Tobias Hartman, was minister of the Presbyterian church in Mesa, and one of his assignments was to minister to the Gila River community in the Casa Grande, Sacaton, and Maricopa areas. Wrigley Company donated 640 acres (worth about $1 per acre) of raw desert land in Maricopa to Hartman's grandfather for partial payment of his missionary work.

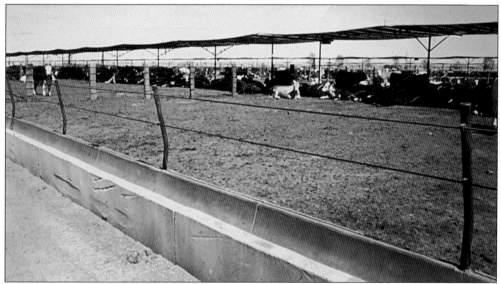

Prior to the 1960s, the cattle-feeding pens were located on Washington and Forty-eighth Streets or down in the river bottom in Phoenix. When the great floods hit in 1965, all cattle feeding lots were devastated. They lost a great deal of money that year as well as cattle. Recognizing the need to move their feedlots, Maricopa farmers zoned a section of land east of Maricopa as "Cowtown" and invited the feedlots to move to Maricopa. Tovrea and Christopherson Cattle Company relocated southeast of Maricopa and Porter Roads. Smith and Kelly Deed Mill came next, and Producers Livestock Association followed. At one time, the Maricopa-Stanfield area was the biggest cattle feeding area in Arizona.

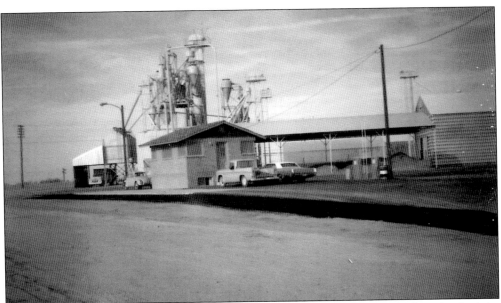

The Smith and Kelly Feed Mill was built in November 1966 as a simple batch plant that had the capacity to mill feed for 25,000 head of cattle. In the foreground is a small office building with a basement, kitchen, sleeping quarters, and bathroom. The feedlots bought grain and hay from the farmers, and it became a win-win for both parties.

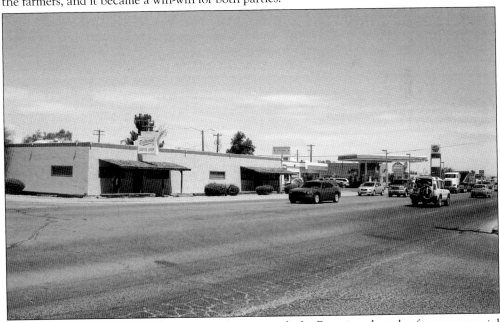

Headquarters Buffet provided a meeting place not only for Rotarians but also for many special occasions over the years. It included a restaurant, meeting room, and bar. The following humorous memory for one customer at Headquarters Bar was hearing the exchange between two farmers who had discovered someone had stolen one of their cars: "Jack, what I can't understand is why they stole your old beat-up 1964 dirty car with a truck bumper and big wheels, when my shiny new car is sitting right here beside it." Disgustedly, Jack replied, "Ed, they know a good vehicle when they see one."

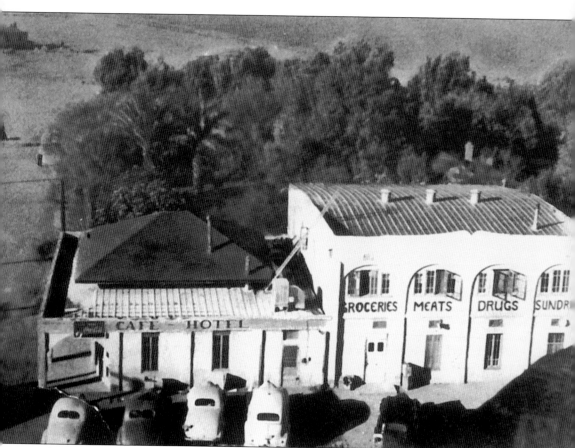

The Maricopa Post Office was located in the Maricopa Hotel from 1936 to 1953. Trains transported all the mail during this time, and the post office was in the hotel. However, in January 1954, the post office moved to a new building in the Honeycutt Shopping Center, south of the track, and two trains delivered mail daily. The No. 6 from the east came about 6:00 a.m., and the No. 9 arrived from California at 9:00 a.m. Most of the mail delivered to Maricopa came from No. 6 and the east. In the afternoon, the outgoing mailbag was attached to a clamp on a pole next to the train tracks. When the train came, a Y-shaped arm extended from the mail car and picked up the mailbag at full speed. Postmaster Fred Cole received a government contract of $150 per month to meet both trains six days a week and pick up the mail. Harry Brock, Maricopa's first permanent rural mail carrier, lived in the hotel when it burned in 1954 and paid $10 dollars a week to rent one of the 11 rooms upstairs. There was a restaurant with a U-shaped bar downstairs, and a few other rooms were used for offices.

This photograph is one of the few available that depicts Maricopa's two water towers. The front water tower collapsed during a storm in 1973. Both towers were made of steel, and each held 500,000 gallons of water. Five-year-old John Cole is standing in front of the small depot and water tanks.

Fred and Naomi Cole came to Maricopa in the early 1950s and moved into the newly constructed housing project on Edwards Road. Naomi is standing in her backyard with Amy and John Cole. Fred was not only Maricopa's postmaster for years but was also the first postmaster trainer in the Denver region in 1962. As a postmaster trainer, he traveled throughout the region to assist other postmasters.

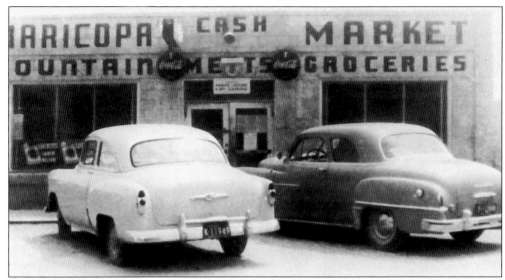

The Maricopa Mercantile, shown above, was one of only two main grocery stores in Maricopa during the 1950s and 1970s. It carried almost everything one needed—food, clothes, shoes, hardware, and so on. Jay and Golden Baldock, shown below, came to Maricopa in 1952, and for 30 years, they worked long hours 6 days a week selling food, dry goods, and most other necessities requested by local residents. Born in Mangum, Oklahoma, in 1916, Jay Baldock lost the only parent he knew when he was barely a teenager. His mother was somewhere in the United States, and when his father died, he started hitchhiking across country during the Depression to find her. (Oral History Project.)

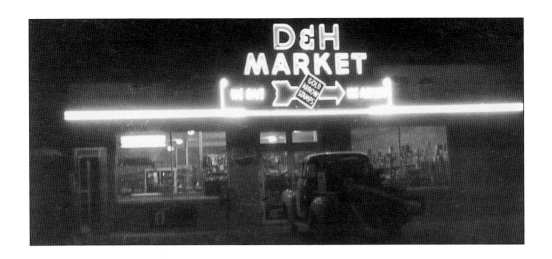

Built in 1954, the D&H Market was located in the Honeycutt Shopping Center, south of the tracks in Maricopa. This market, owned and operated by C. P. Honeycutt and John Daugherty, had a large, bright neon sign on top of the building. One day a man came into the store and said that it was like a beacon to him and other pilots. The neon sign assisted them in their approach to the dirt runway south of town. John Daugherty was one of the local football team's greatest supporters (below). He hardly ever missed a game, traveling the football circuit wherever it went and providing them with encouragement and food. He was also a source of encouragement and inspiration to many of Maricopa's young people who needed a helping hand throughout the years.

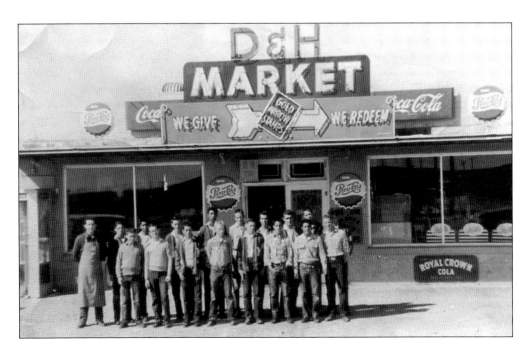

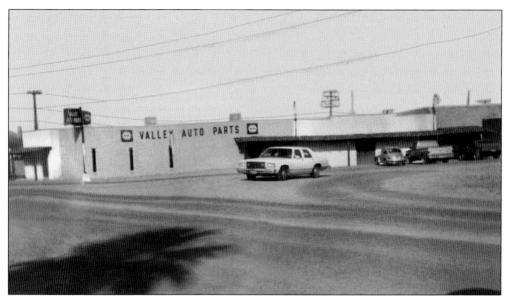

Don and Esta Rae Pearce brought their family to Maricopa to start the Valley Auto Parts store (above) in the 1960s. In the beginning, the small building was about 16 by 45 feet and contained tractor, truck, and auto parts. Later the building expanded to more than twice the space. Because of the many fire fatalities in Maricopa, Don Pearce started the first all-volunteer fire department.

Maricopa citizens have never been short of talent or enthusiasm for laughter. Local artist Patricia Carter wrote a play and musical titled *Wow! What a Dame*. It depicted a moment from the past at Maricopaville that included a popular entertainer and singer of that time, Lillie Langtry. Those pictured include Viola Baugus, Ken Skousen, Fred Cole, and Harry Brock.

Hubert William "Trigger" Ashby, pictured on the left, transferred to Maricopa from Eloy in 1953 to serve as its law enforcement officer. He was not a big man in stature, but when he spoke, people listened. During World War II, he was part of an elite group of men who took up arms to serve their country, the Bushmasters. After he resigned from his position as deputy in Maricopa, he managed Headquarters Bar and entertained its patrons with unlimited humorous stories over the years. If he ran out of stories to tell, he made one up to fit the occasion. He greeted everyone who entered the door with a big smile and a joke for 25 years. In the late 1960s, many families seeking a better way of life bought mini farms in the Hidden Valley area, pictured below. Through a series of fund-raising activities, they bought a fire truck to combat the many fires and constructed a community building in 1978.

When Pam Marlar first saw her anticipated field of dreams at Thunderbird Farms, it turned out to be a field of dirt that once belonged to a farmer. The family labored days, nights, months, and years to change the field of dirt into their home. This dedication and hard work brought forth bountiful vegetable gardens, numerous farm animals, and lots of space left for homemade forts and bicycle racetracks. Pictured at left is Buddy Marlar with granddaughter Michelle. Buddy Marlar can remember the early years at the farm, when rains followed the dust storms that left the dips and washes full of raging waters. No one could get into town or work for days at a time. Today there are paved roads and freeways to facilitate traveling, and the Marlar clan, seen above, can enjoy their paradise in the desert.

Tonya Groff grew up at Thunderbird Farms, rode horses, and participated in gymkhana shows and 4-H activities. She said, "Our next door neighbor, Al Ruiz, organized a Ranger Rick Club for the kids in our neighborhood and taught us about Arizona's plants and animals. The group lasted for several years. We all learned a lot about life, survival, and each other, because of the willingness of people like Al who shared their life-long experiences with us." Tonya Groff is pictured with her daughter.

Due to children drowning in the canals on farms in Maricopa, the local Rotary Club decided to build a swimming pool. John Smith and Fred Enke donated 3.5 acres east of Maricopa, just off of the Casa Grande Highway, for the pool and park. The estimated cost of the pool was $50,000, but Rotarians (above) provided part of the labor and reduced the cost to half.

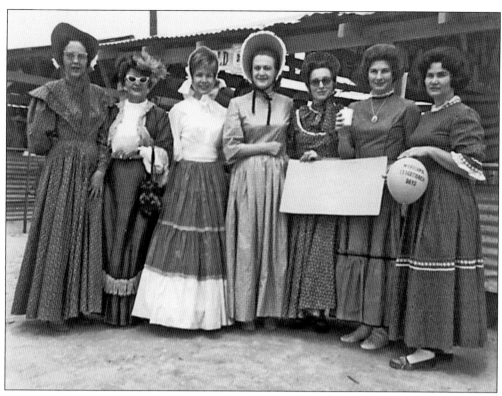

In order to pay off the mortgage and celebrate Maricopa's rich heritage, the Rotarians organized the first "Stagecoach Days" in 1958, pictured above. Pictured on the left are Elbert and Ellen Young, who are enjoying this festive event. They settled in Maricopa in the early 1950s. They cleared the Jack Ralston desert land of mesquite brush, dug a well, and planted cotton. Later, Young helped Sam Teel turn his raw desert land into farmland. A trucking and combine business was started in 1958 that became a family affair with their two youngest boys, Nolan and Melvin. "Dad kept the combines going, and Mom drove trucks," recalls Nolan. The family harvested crops from Texas to Colorado and back to Arizona for the milo harvesting season, in October and November.

Oliver Anderson has worked on the Anderson farm since the 1950s, and even though he is retired today, the farm constantly pulls him back. He became manager of the farm in 1955, when he graduated from the University of Arizona. In 1956, he met and married Hermina, who served as the music director in the Community Church for many years. Their four children grew up on the farm, and Kelly continues to farm today. During his farming years, Oliver created one of the most productive farms in the state of Arizona. He was a hands-on farmer who very seldom left the farm—that is unless it had something to do with 4-H activities, Rotary, or church. Enjoying Stagecoach Days are, from left to right, Hermina, Troy, Kelly, Oliver, and Lynn Anderson.

Phyllis Rust (left) was born in Nova Scotia, Canada, and moved to Maricopa in 1953 with her husband, Bart Rust (below right), and their two young children. She was unaware of how this would change her life. Her first encounter with Maricopa involved a severe case of culture shock at the Maricopa Mercantile, when Bart introduced her to "a crusty old lady" and then left them to shop for groceries. The lady carried a humongous black purse with a snap on top. During their conversation, she opened the purse to reveal not only her cigarettes but also a pint bottle of whiskey and a pistol. Their farm was located out in Hidden Valley, and Bart built a huge redwood fence around the property to keep out rattlesnakes. That summer they killed 59 inside the fenced area. Despite Wild West characters, tornados, flash floods, and rattlesnakes Phyllis remembers the time they lived in Maricopa as the best years of their lives.

The Maricopa Rotary Pool, built to Junior Olympic specifications (75 by 36 feet), includes a wading pool for youngsters who are just learning how to swim. Just before the pool opened every year, there was an all-call for community members to lend a helping hand cleaning the slime and debris from the pool. Maricopa's early swimming team, above, consisted of about 20 swimmers and a couple of tough coaches. This diminutive team grew into more than 40 participants, below, with some of the best swimmers and competitors at Pinal County swim meets for many year.

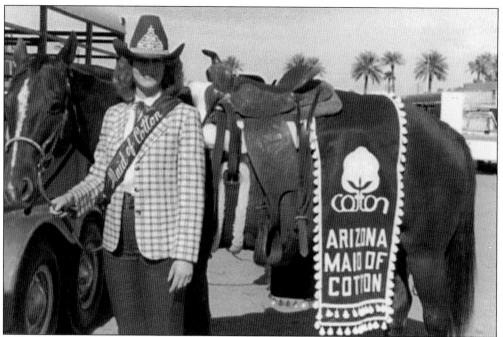

Debbie Pratt of Maricopa reigned as the Arizona Maid of Cotton in 1980 and 1981. She was definitely a farm girl. She drove a tractor, plowed the fields, and was in charge of 30 to 40 calves when she was only 13 years old. This indomitable farm girl bought her first car (a Karmann Ghia) from Harry's Used Cars in Maricopa with money she received from trapping gophers, which was earned when she was only 12 years old.

The humble beginnings of the First Baptist Church took place with the Charles Chance and Herschel Kenmore families holding Sunday school classes under a mesquite tree across the street from the elementary school in the early 1950s. Later services were held inside the school, and as its membership grew, the First Baptist Church building was constructed in 1955 with help from local farmers, who donated bales of cotton for its construction.

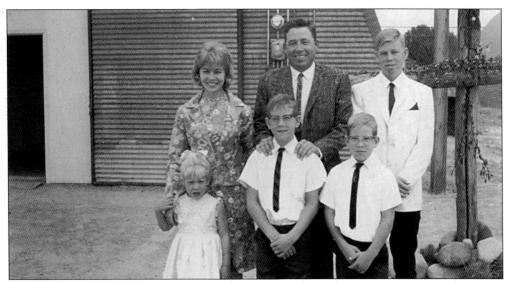

The Maricopa Community Church started as Sunday school classes in 1963 held in the former Honey Cup Café, located southeast of Maricopa. Growth necessitated moving the services to a large Quonset hut north of the housing project on Edwards Road, which is shown above. Many lasting memories for its members were created at this church. Some memories include Christmas programs, baptisms, Bible school, dinners, and surprises like a collapsing pew row, visiting critters, and shockwaves from passing trains. The building was directly behind the railroad tracks, and thundering trains created such a ruckus that all lessons and sermons had to cease until they passed. The construction of Maricopa Community Church began in 1973 on Hathaway Street with a building fund of about $8,000 and with much of the supplies, labor, and money being donated.

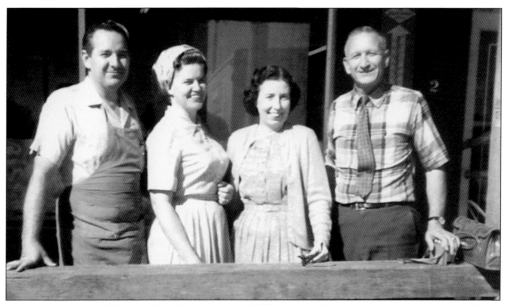

In the summer of 1958, the families of Gerald Williams and John Daugherty started the local congregation of the Church of Christ in the Williams home on the Calvin Rose farm, off of Papago Road. Classes for children were held in one of the bedrooms or in the kitchen. Later services were held in the Daugherty home in Maricopa until the church was completed in the spring of 1959. Gerald and Johnny spoke on alternate Sundays, and the church had the occasional guest speaker. From left to right are John and Betty Daugherty and Elva and Charles Fletcher.

A Chandler man donated a lot to build the Church of Christ, which is west of Maricopa High School on McDavid Road. Wylie Burns, a carpenter and member of the Church of Christ in Casa Grande, undertook the task of building the church. Church members painted the benches brown and tiled the floor. Each Sunday morning, before services, members lifted the benches and slammed them to the floor, which was done in order to dislodge any scorpions hidden underneath.

The history of Maricopa's Church of Latter Day Saints (LDS) started with a small group of members who attended church in Chandler. A Mesa man donated a lot north of the tracks on Hathaway for the building of a church. The United Methodist church in Chandler had an old building they auctioned off for a bid of $1. On May 3, 1959, this building was moved to Maricopa on Hathaway Street. Seminary, a scripture study class for high school students, was held every weekday morning before school in 1974 at this old church building, which is pictured above. Pictured below, a new LDS church, under the direction of Bishop Park, was completed in 1989 on Honeycutt Avenue, south of Maricopa High School.

Boy Scouts are a high priority for the LDS church. Many young men from Maricopa have grown up with this program. The first two Eagle Scouts from the Maricopa troop, Thad Miller and Ben Snow, were honored on November 20, 1983, which was when Marion Luster was Scoutmaster.

Our Lady of Grace Catholic Church is a parish of the Diocese of Tucson, Arizona. Bishop Gerald F. Kicanas established the parish on January 13, 2007. According to pastor Fr. Marcos C. Velasquez, "We seek to preach and teach the fullness of the Gospel in accord with the teachings of the holy Roman Catholic Church by loving God and neighbor. We are dedicated to proclaiming and living our faith in the Lord Jesus Christ!"

Six

EDUCATION
SCHOOLS WITH PERPETUAL GROWTH

At Maricopa Wells, students were home taught or sent to boarding schools. However, only a few children lived at Maricopa Wells. Jane Moore sent her twin daughters, Clara and Susan, to a famous boarding school in San Francisco during the 1870s and 1880s. The sister of Charles D. Poston, the father of Arizona, owned and operated the boarding school.

Schools have always been of prime importance to the Maricopa people. The community's first classroom, in 1912, consisted of an abandoned house built of railroad ties and bridge timbers located north of the tracks with 1 teacher and 10 students. In 1914, community women assisted in laying the foundation for Maricopa's first permanent schoolhouse south of the tracks, which played host to 14 students. Parents volunteered in the classrooms, where plays, singing, and playing the piano or another instrument were encouraged as well as the required core curriculum.

Arizona's 1950 population of 749,587 almost doubled by 1960, and Maricopa's classrooms overflowed with this growth. Taxpayers passed a bond to build a high school, and the first class at Maricopa High School began with 28 freshmen and 5 teachers in 1955. A total of 10 students received their diplomas at its first graduation ceremony in 1959. In 2000, there were approximately 600 students enrolled at Maricopa High School and Middle School, and 550 students were enrolled at Maricopa Elementary School, which totaled 1,150 students in Maricopa schools.

After the incorporation of the City of Maricopa in 2003, its population exploded with growth again, and by 2006, students were taught in the hallways, in the libraries, on the playgrounds, or wherever space was available. The school district was in overdrive building new campuses as fast as possible. The old elementary and middle schools were demolished to make way for a new high school, and today there are six elementary schools, from kindergarten to the fifth grade, with 3,653 students; there are two middle schools with an enrollment of 1,466 students; and one large high school campus has 1,500 students for a total enrollment of 6,619.

Maricopa High School graduated 280 seniors in 2010, but their formal education did not end on graduation night. These bright, energetic, and ambitious young people are college-bound. During the final days at Maricopa High School, 123 graduating seniors were recipients of $1.3 million in scholarships.

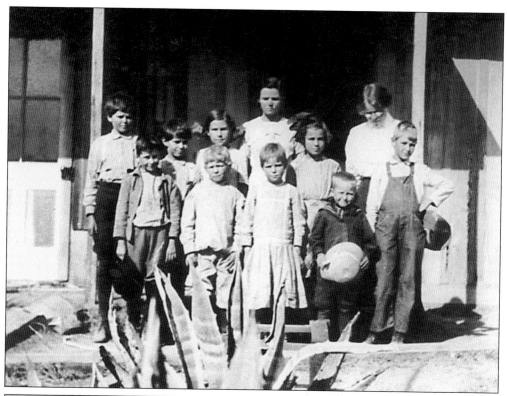

A small house north of the railroad tracks, shown above, served as a school for 10 children and 1 teacher in 1912. George Cole, who homesteaded 160 acres in Maricopa, owned the house. The school was built of railroad ties and bridge timbers. Laura Parsons (left), from Nogales, became the school's first teacher when the school opened its doors in 1912. Parsons taught Maricopa students in the first through the eighth grades until 1914.

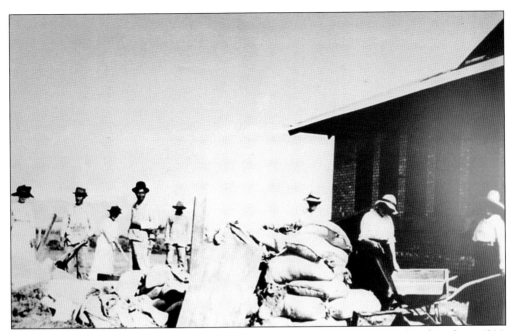

The women of Maricopa laid the foundation for a new school south of the railroad tracks in 1914. This dandy new redbrick building consisted of 2 rooms, 2 acres of land, 1 teacher, and 1 teacher's aide, and it cost $5,000. The school's enrollment was approximately 25 to 45 pupils until World War II. Shown are Clara Williams, Mrs. Tom Hawley, Susie Smith, Marcella Cole, and Alice Drake.

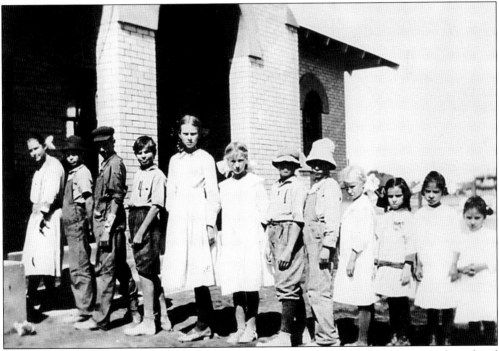

This redbrick schoolhouse, built in 1914, was located at the corner of John Wayne Boulevard and Honeycutt Avenue. Today this land is part of the Maricopa High School Baseball Field. Nellie Still, the teacher, taught all subjects to these 12 students.

Nellie Still was a fresh graduate from Tempe Normal, and her father accompanied her to Maricopa to apply for this position and to ensure she was safely settled. After leaving Maricopa, Nellie moved to Tucson, and she later became a full-time art instructor for all of the elementary schools in Tucson. She passed away in Tucson in 1951.

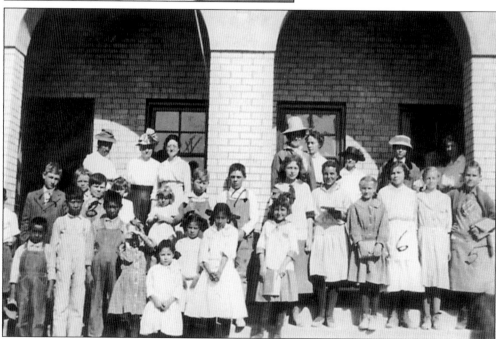

Mrs. Peene taught all eight grades at Maricopa Elementary School from 1915 to 1920, with the assistance of several parents. The schoolhouse had two rooms, but according to Marjorie Deal Smith, who attended the school, only one was used for instruction.

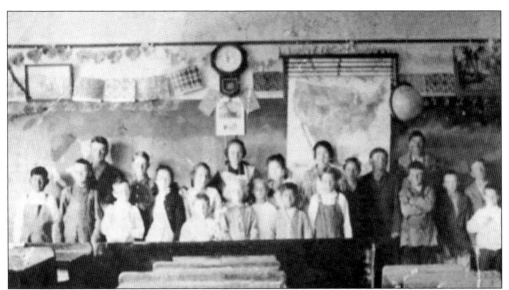

Perry Williams's grandson Hiram Carlyle is the boy on extreme left in the photograph above. Every time the old man with a white beard (his grandfather Perry) came to school, Hiram knew he would be going to the store and getting a bag of candy. Ruth Lipscomb, pictured to the right, taught all eight grades during 1920 and 1921. One of her eighth-grade students was Ruby Deal. Ruby's father, Arthur Deal, was a widower and a member of the board of trustees. Ruth Lipscomb resigned at the end of the school year and married Arthur Deal. The people of Ak-Chin community were important customers in the Deal store. Many items in the store, such as axle grease, yard goods for colorful dresses, poplin shirts, and certain food items, were stocked especially for the people of Ak-Chin community.

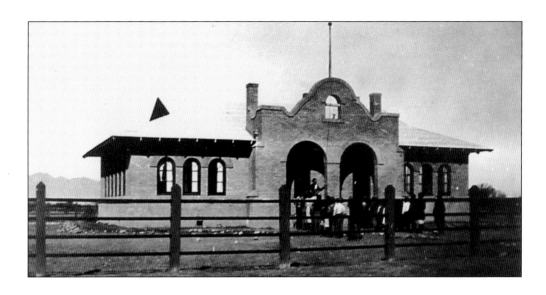

Perry Williams donated four lots in 1914 for this new school. The school, pictured above, had a fence around it that consisted of four iron pipes per span, making the fence about 5 feet high. The toilets were just west of the building in a little wooden shack. A small water tank stood at the southwest corner of the schoolyard. Inside the building, there were coat racks and shelves in a small room on the north side. The room was about 10 feet wide and 16 feet long. Blackboards were on the west end and north side of the classroom. Each class had its own area in the room. Miss White (with the hat below) taught Maricopa children from 1921 to 1927.

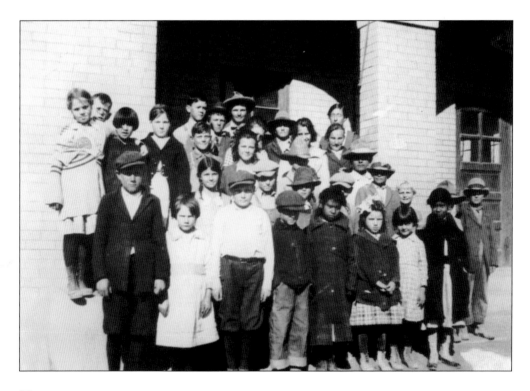

Donald DeHart (above) said his teacher, Mrs. Folsom, was a small lady. One day she got the idea she wanted to ride horses and found one to rent. The 14-year-old horse stood about 6.5 feet to the top of his shoulders and was coal black. He had been a roping horse in his younger days. The pumper, Charley Barker, had rounded up a small young pony that was full of life and hard to handle. Charley bet Mrs. Folsom that his horse could outrun her old horse. The race started at the DeHart house and ended at a large ravine about a quarter-mile east. Charley's young feisty pony never had a chance and was left in the dust. In 1927 and 1928, Mrs. Stedham (below, third from left), was the teacher at Maricopa School.

Here is the water tank in the playground at the elementary school in 1928. Southern Pacific Railroad furnished all water to Maricopa and the school during the early train days. Those pictured are, from left to right, Helen Smith, Zella Wisner, unidentified, Donald DeHart, Robert DeHart, Jose Ruiz, and Dorothy Smith.

Miss Tremble taught students in 1930. Donald DeHart recalled that he and his brother earned extra money by cleaning the blackboards after school daily. They used the money to buy their mother a new set of dishes at the end of the school year.

Gladys Kilcrease taught first through eighth grades in 1931 (above), when the enrollment was between 40 and 45 students. She lived with the Dallas Smith family, whose house was located southwest of the railroad tracks. During the 1930s, the school year often ended with plays and recitals. Marjorie Deal remembered the school health play included students taking on the persona of different food groups in 1935. The class sang the "May Song," and mother-and-child piano solos and duets finished the program. The love and appreciation of music played a major role in the lives of Maricopa's people. Richard Carlyle's teacher was Pearl Eckart during the 1945–1946 school year. Pictured below, Richard is located on the back row on the extreme left.

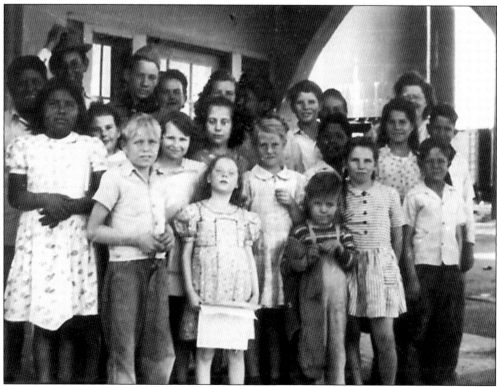

TEACHER'S CONTRACT

THIS CONTRACT, made the _____27th_____ day of _____April_____, A. D. 19_42_, between
_____Pearl Freeman_____
_____and the
Board of Trustees of_____Maricopa_____, School District No._20_
_____(Name of District)_____
in the County of_____Pinal_____, State of Arizona:

WITNESSETH, That the said _____Pearl Freeman_____, who
holds a legal certificate to teach in the public schools of Arizona during the period of this contract,
hereby agrees to teach such grade, grades, or subjects in the public school of said district as the
Board of Trustees, principal, or superintendent may assign to_____her_____, for the period of_____nine_____
(_____) months, commencing on the_____day of_____Sept_____, 19_42_, and well and
faithfully perform the duties of teacher in said school, according to law and the rules legally
established for the government thereof, including the exercise of due diligence in the preservation
of school buildings, grounds, furniture, apparatus, books and other school property.

In consideration of said services, satisfactorily performed, the said Board of Trustees, in behalf
of said school district, agrees to pay the said_____Pearl Freeman_____
the sum of_____One humdred sixty & No/100----------------160:00_____dollars ($_160:00_) per month.
Done at a legally convened meeting of the said Board of Trustees this_____13th_____day of
_____April_____, 19_42_.

_____Pearl Freeman_____
(Teacher)

Trustees of School District No._20_
_____Pinal_____
_____County, State of Arizona.

_____Jack F. Whalen_____
_____O. P. Sloan_____
_____D.H. Smith_____

Before me this day personally appeared_____

parties of the above contract, and acknowledged that they signed the above contract of their own
free will, and for the consideration therein expressed.

Date_____

Carl and Mildred Engelmann signed a contract in 1946 to teach 45 Maricopa children. Carl
Engelmann's contract was for $2,800, and Mildred's was somewhat less. The school provided the
Engelmanns with a three-room house with a bath but no running water. Their home was located
across the road and south of the school. After modernizing the inside of the house, they began
to clear the yard. In one afternoon, while Carl Engelmann was installing the fence, he killed five
rattlesnakes. Mildred Engelmann remembers waking up one night in 1946 to a swishing sound. She
looked out the window and discovered that they were surrounded by water. Stranded for several
days, they had two small children and very little food. A plane flew over one day, searching for
people who might need help, and a man in a boat rowed up to the house to check on them another
time. However, the catalyst for leaving Maricopa was not due to the flood that left them stranded,
rattlesnakes in their yard, stray cattle, and limited amenities, but the lack of churches.

Mr. and Mrs. Cates moved to Maricopa and taught its children from 1947 to 1949. By 1949, the school enrollment had increased enough to hire four teachers, Milton Lewis and his wife, Mrs. Birmingham, and Mrs. Aly, who are pictured above. Mrs. Aly lived in a little trailer that was located at the Santa Rosa Ranches. According to Alice Claxton, Mrs. Aly got up every Sunday morning, collected children around Maricopa, and took them to church. The church was in the 1914 schoolhouse.

At the end of each school year, teachers took older students on field trips that included picnics in the desert or a day of swimming at the Salt River. After the formal eighth-grade graduations, these students commuted by bus to Casa Grande High School. It was a long trip, and if it rained, the roads were impassable, and students did not go to school. It was a difficult time for those students who wanted a degree and had limited resources. Pictured at left is Bobbie Cooper Honeycutt Stewart. The others are unidentified.

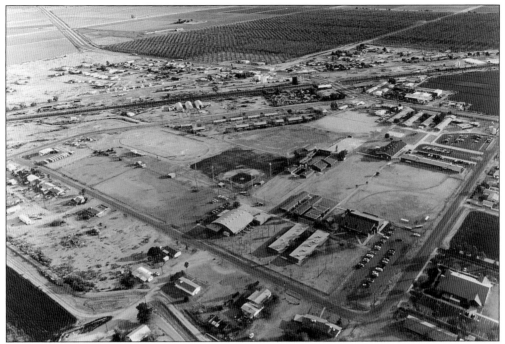

Maricopa Elementary School started to grow after World War II. Land was cheap, and Maricopa's soil was excellent for growing cotton. This new agricultural boom brought many families into the area, and with these families came the need for a larger school. It became necessary to move three trailers onto the school property for temporary classrooms, with some classes held under the tamarisk trees. In the fall of 1950, John Evans was principal, and the teaching staff had doubled in size.

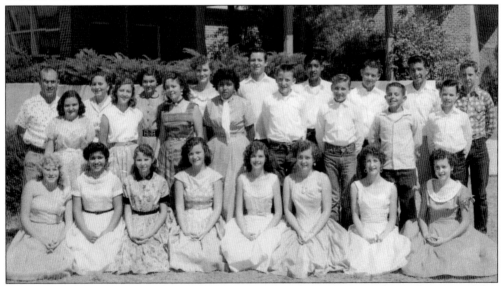

These students graduated from the eighth grade in 1955 and were ready to take on the responsibility of being the first Maricopa High School graduating class. In the fall of 1955, there were 28 students who entered as freshmen and 5 Maricopa High School teachers. Many of these students became part of the first Maricopa High School graduating class in 1959. (Juan Sanchez family.)

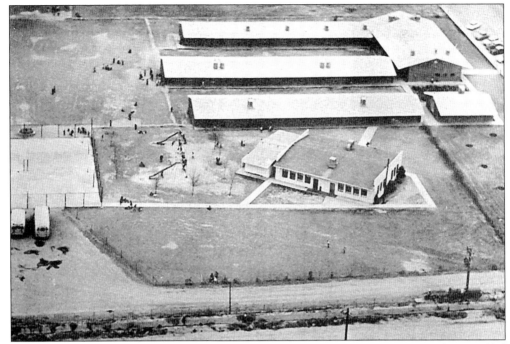

By 1955, there were 383 students enrolled at Maricopa Elementary School (above) and 28 enrolled in the first high school (the building in front with many windows). In 1960, Maricopa Elementary School's enrollment had grown to 600, and the high school's had increased to 90.

Maricopa Elementary School was kindergarten-through-sixth-grade school during the 2005–2006 year and had an enrollment of 702 students. This was the last year this campus, which is pictured above, was in operation because of hyper-growth in Maricopa. The school was demolished to make space for the expanding high school. As of August 2006, the new Maricopa Elementary School offered kindergarten through the fifth grade at its new location in the Tierra North subdivision with a capacity for 850 students.

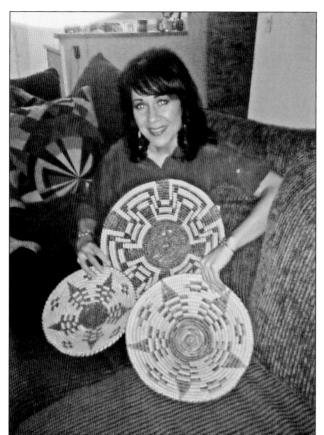

As part of the school's multicultural fair celebration in 2010, Saddleback Elementary students had the privilege of hosting the vice-chairperson of the Ak-Chin Council, Leslie Carlyle-Burnett. Burnett responded to many student questions and finished the sharing of her culture by advising, "Whatever culture you are, that is who you are, and you want to remember that; otherwise, you lose your identity." Burnett (left) is holding a basket (the large one) made by her great-grandmother Julieanna (Nancy) Antone Narcia, who was born in 1888 and died on August 15, 1959. Her grandmother Tillie Carlyle made the two smaller ones. (Leslie Carlyle-Burnett)

Butterfield Elementary students honored their families' veterans by bringing in photographs and stories about family members who served or are serving their country today. The Veteran's Wall idea came from one of Butterfield's second-grade teachers, Stephanie Rhinehart, who is part of a family that has served in the military for decades.

Using a 20-foot-tall globe, students at Santa Rosa Elementary School and their parents "toured the world," visiting different continents and countries. World-related projects assigned to specific grade levels to study were shared with parents. Also, the band and choir entertained everyone with world-themed music selections. (Joyce Hollis.)

Desert Wind Middle School's sixth- through eighth-grade students walked away with the Academic League Championship and traveling trophy in 2010 against their competitors, Maricopa Wells Middle School. (Joyce Hollis.)

The Association of Junior High Student Council State Convention was held at Fort McDowell Resort and Convention Center on May 6, 2010. Maricopa Middle School students met and shared activity and fund-raising ideas in addition to dancing and hearing a motivational speaker. Each council competed for points on written reports about fund-raising, school, and community involvement; digital presentations; scrapbooks; and school spirit projects. All reports were graded on a 100-point system, and Desert Wind received 28 out of a possible 32 points to win the Honor Council award. This is the highest honor possible for a first-year council. Those pictured are, from left to right, (first row) Eli Reynolds; (second row) Victor Gonzalez, Chelsea Trejo, Shannon Stone, and Mary Morton; (third row) Bryce Crosbie. (Joyce Hollis.)

Maricopa Wells Middle School students are loaded with talent, and seventh-grade student Nicolette Sanchez definitely has it. One of Nicolette's art pieces took center stage in the art studio toward the end of the school year in 2010. Her assignment was to create something showing who she is. Therefore, she combined her love for animals with her love of art and drew a picture of her cat. (Joyce Hollis: InMaricopa.com.)

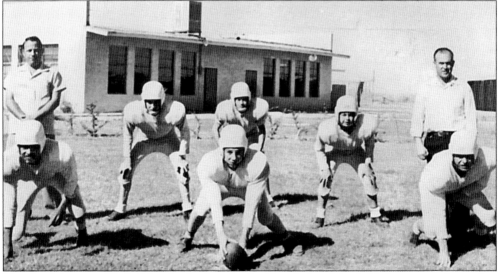

The first Maricopa High School, which is the building behind football players, was located at Maricopa Elementary School and served only freshmen in 1955. Its first football team registered six players, with no subs, which meant there was no room for error. Their first game was with the Monsters at Gila Bend, and the Mighty Rams were charged up and ready to take them on! The final score was not even close: 55-0. Maricopa's score was the lesser of the two.

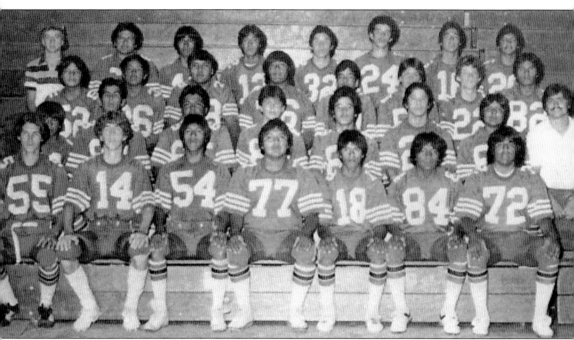

Fast forward to the 1981–1982 school year and meet Maricopa High School's state football champions. Since its humble beginning in 1955, Maricopa High School has won the state baseball championship five times. The State Player of the Year title went to Louis Manuel in the 1979–1980 baseball season. John Traylor averaged 27.9 points, 20 rebounds, 7 steals, and 5 assists per game in the 1971 basketball season and was named State Player of the Year. Maricopa High School has taken home the big trophy for the state track and field championship three years in a row: 1974, 1975, and 1976. The Glendale Arena became the showplace for Maricopa's wrestlers in 2005. Carlos Villa secured his second consecutive state wrestling championship in 2005 and finished his season with a fantastic 69-0 record. No other wrestler in the state's history has won more matches in one season. There were other outstanding wrestling achievements at the arena in 2005. Adrian Fierros took second place at his third state wresting championship event. Fierros had won the Class 2A/1A State Wrestling Championship the previous two years.

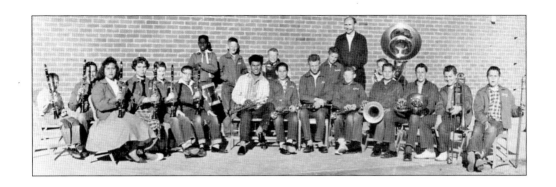

The first Maricopa High School Band consisted of about 20 students, pictured above, under the direction of Charles Mattern in 1960. By 2008, the Maricopa High School Band, under the direction of Ivan Pour, qualified for the State Marching Festival and received a rating of "excellent" at Eastern Arizona College Band Day. In addition, the marching band achieved the highest possible rating of "Superior" at the Arizona Band and Orchestra Directors Association (ABODA) State Marching Festival for Division IV. By 2010, this band, pictured below, has increased to more than 62 performers from less than 40 just two years before. On September 25, 2010, the band attended its first competition and received caption awards for outstanding auxiliary (color guard) and outstanding visual performance. (Below, Maricopa High School)

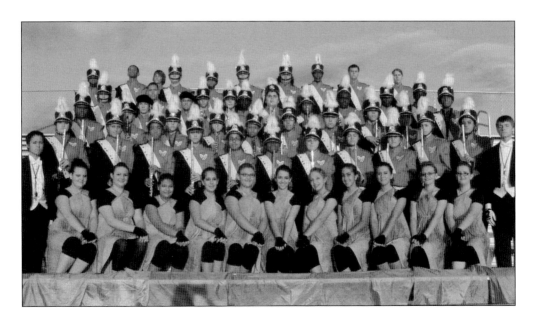

Maricopa Middle School Space Kids in 2001 (above) won the grand prize in the Honeywell–Fiesta Bowl Challenge, beating out academic teams from all around the state. The four-member team designed a model that represented their vision for a self-sufficient international space station that would house 100 people for one year. The students then had to present their report and project in front of a packed house at the Challenger Space Center in Peoria, after which they had to fend off questions from Honeywell engineers and members of a space shuttle flight team. As grand prize winners, the students and their coach, fifth-grade teacher Nancy Rollins, were flown to Kennedy Space Center for a private guided tour of the base and were recognized on the field during halftime at the Fiesta Bowl. Pictured from left to right are Mario Bandin, Johnnie Ray Cyr, Kelsey Early, Ronnie Lyn Cyr, and teacher Nancy Rollins. Most of the girls at Maricopa High School in the 1950s and 1960s (below) took home economics, which included sewing and cooking classes.

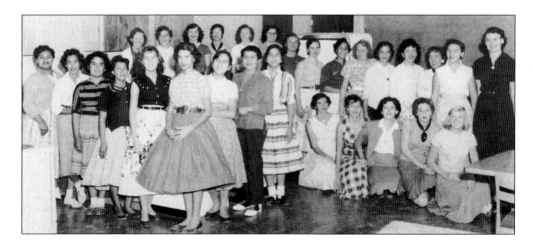

Maricopa High School had an enrollment of 566 students in 2006. By 2010, that enrollment exploded to more than 1,500. Today Maricopa High School's state-of-the-art buildings are surrounded by a huge courtyard (above). The school offers a wide variety of classes, including a class called We the People (below). This class teaches students about citizenship and government, and statistics indicate that this class helps raise the advanced placement (AP) test scores of the students. Maricopa's students have competed in the Congressional District and at the state level the past four years and have been named first place three times and second place one time. Their teacher and coach, Bernadette Russoniello, is a College Board/Educational Testing Services exam reader for AP Government and Politics. She has also attended several workshops, seminars, and the national We the People finals in Washington, D.C. (Below, Maricopa High School.)

The Link Crew at Maricopa High School are trained mediators who help resolve campus conflict, which helps reduce the incidents of violence. They donate countless hours to tutoring students in need of additional instruction and are friends to anyone in need. According to their advisor and coordinator, Krista Barrett, they are "motivators, leaders, mediators, and teachers who guide freshmen to discover what it takes to be successful during the transition to high school and help facilitate freshman academic and social success. This group of amazing students has won the hearts of teachers, administrators, and community leaders/members with their unwavering devotion to others." They also work with people outside of the freshman class who need assistance. (Maricopa High School.)

When Maricopa High School students petitioned to name the new baseball field after Matt Huffman, dedicated Athletic Director Mat Reese stated, "Ten . . . Fifteen years down the road; I want students to ask, 'Who is Matt Huffman?' Then benefit from hearing about his character and contributions he made to this school and community." Students like John DePaulo will answer, "I knew Matt for three years and I learned something from him everyday I spent with him." Coach Kurt Kieser responds, too, "He's the kind of guy every coach wants on his team and every parent wants their kid to be." On January 3, 2002, young Matt collapsed and died while out jogging. The sports editor of the *Casa Grande Dispatch*, Ed Petruska, describes Matt Huffman: "An ideal role model . . . all-around athlete who loved competition and worked hard to get the most out of his ability. And above all, a young man who thanked God for all he had and lived by his strong Christian beliefs."

At Maricopa High School's 2010 graduation ceremony, seniors, totaling 280 in all, received not only diplomas but also encouragement from their classmate, salutatorian Wendy Tran. She stated, "The curtains are closing, and the students before me are the stars of this show—step forward and live life to the fullest—embrace life!" Karla Munoz, class valedictorian, reminds follow graduates that "more than anything we have learned how to learn" and to go forth regardless of obstacles to "achieve your goals." With the "Rambo spirit," senior class president, Caitlin Snow, presented the class gift to the school, a new Ram mascot, Rambo the Ram. Out of this outstanding class of seniors, 123 were awarded $1.3 million in scholarships at the annual Night of Excellence awards ceremony at Maricopa High School. (Joyce Hollis: InMaricopa.com.)

Seven

MARICOPA
ONE OF THE FASTEST
GROWING CITIES IN THE NATION

Maricopa is the only community in the nation that borders two Native American reservations, the Gila River Reservation to the north and Ak-Chin Reservation to the south. Maricopa and Native American roots date back to the 1850s, when they shared common grounds near Maricopa Wells, Maricopa's first location. Today they are separate entities, but they still continue to share the same schools, celebrations, and many of the same struggles.

Maricopa became Arizona's 88th city with its incorporation in 2003. Then it took on a life of its own and literally exploded with growth from a small farming community in 2000 with a population of 1,040 to a city of 15,934 in 2005. At the peak of its growth in August 2005, it issued 791 permits, with the population predicted to top 100,000 by 2010.

Today Maricopa, with a population of 45,000, takes on the challenges of one of Pinal County's largest cities and offers some of the lowest home prices per square foot in the state. Some of the major challenges for Maricopa in the next five years are transportation, flood control, and air quality. However, some of its greatest strengths are its caring spirit and community involvement. Like its predecessors, Maricopa continues to be composed of many cultures that influence and celebrate all of its citizens through arts and crafts, food, music, dance, religion, and holidays that enrich the lives of everyone. Maricopa offers a fine quality of living with its many churches, businesses, state-of-the-art library, beautiful lush parks, recreational programs, golf courses, friendly people, and unlimited opportunities. The Sierra Estrella and Haley Hills are ideal for picnics, studying petrogyphs, and horseback riding. West of Maricopa is Arizona Soaring, which offers the only flight training school of its type in the country. South of Maricopa is Shamrock Farms Dairy and Harrah's Ak-Chin Resort, and within a couple of miles from old historic Maricopa Wells is the Dunes Golf Club. Another golf adventure is the Rancho El Dorado Golf Course, located in the heart of Rancho El Dorado.

The historic city of Maricopa is rich in history, innate beauty, and friendly people and is a great place to raise a family, grow a business, and enjoy life in the foothills of some of the most beautiful mountains and sunsets in the world.

Arizona governor Janet Napolitano receives the key to Arizona's 88th city in 2003 from Danielle Casey, Maricopa's economic development director. When the City of Maricopa incorporated on October 15, 2003, it was a council-manager form of government, and its governance was through seven council members, with one of its members elected as mayor. On March 14, 2006, the qualified voters of the City of Maricopa elected the mayor, and the city manager was appointed by the city council. Those pictured below are, from left to right, councilperson Will Dunn, councilperson Steve Baker, councilperson Edward Farrell, Governor Napolitano, councilperson Kelly Haddad, Mayor Kelly Anderson, Councilperson Joe Estes, and Vice Mayor Brent Murphree. (Below, Janet Napolitano.)

Maricopa earned the title in 2005 of being one of the fastest growing cities in the United States and one of the best places in the country to build a business. Developers turned the farmlands (above) into hundreds of neighborhoods with beautiful parks and waterways. Today this 88th Arizona city, with a growing population of more than 45,000, takes on the challenges of a busy city. It offers a fine quality of living with its many churches, businesses, parks, and recreational programs. (Right, 85239TheMagazine.)

Vicki Pettes published the first edition of the *Communicator*, a monthly newspaper, in 1996, with Sue Groff serving as its editor. It grew from a monthly circulation of a few hundred to a weekly publication of more than 15,000, providing Maricopa with its first long-term news and advertising source. Shawn Schlegel became the managing editor and publisher of the newspaper in 1997. (Vicki Pettes.)

The publisher of several Maricopa news sources, Scott Bartle, has the honor of being a part of the popular Web site InMaricopa.com, which has instant news and a forum for its readers; the magazine *85239TheMagazine*; and a monthly newspaper, *InMaricopaNews*, that covers in-depth stories and opens communication with Maricopa's leaders and businesses. (85239TheMagazine.)

This beautiful new 8,085-square-foot, state-of-the-art library opened in 2009. It has dropped circular lit walls that highlight Maricopa's history through photographs. In addition to books, the library includes the Maricopa Room, which is used for meetings; the storytelling area; and a computer station. In 2010, the library had the second-highest circulation of any public library in Pinal County, with 23,000 items checked out during June.

ONEBOOKAZ provided an opportunity for citizens to come together to read and discuss books that increase their knowledge and appreciation of Arizona's unique history and culture. As Arizona prepares for its 100th birthday, the Friends of the Library hosted the author of *Trunk Murderess: Winnie Ruth Judd*, Jana Bommersbach, on May 1, 2010, for the adult selection, and the author of *The Three Little Javelinas*, Susan Lowell, for the children's selection. (InMaricopa.com.)

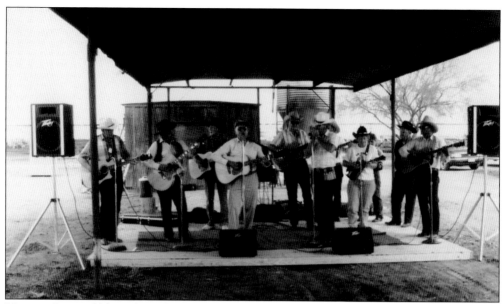

Maricopa's incredible parks and recreational program embraces age groups from babies to senior citizens and provides opportunities for everyone to get out and become acquainted with one another. Honoring and preserving Maricopa's rich heritage with Stagecoach Days allows everyone an opportunity to relive a few moments of yesteryear (above) with live music and dancing. The first celebration of Stagecoach Days in 1958 offered not only some of the best barbecued beef in the West but also provided cutting horse shows with some of the top cutting horse contestants in the country, barrel races, and the greased pig contest (below), in which contestants must catch a greased pig and hold on to it. It can be a timed team event with several pigs or an individual event with one contestant and one pig. (Both, InMaricopa.com.)

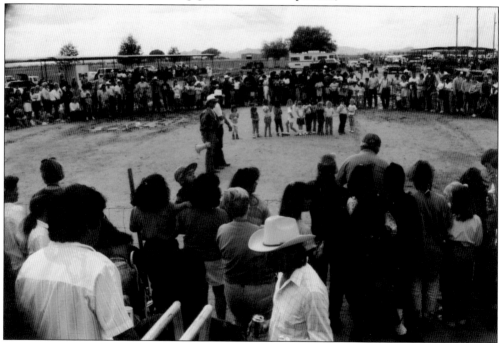

Learning the fundamentals of basketball and good sportsmanship is available through the city, and tennis, golfing, wrestling, running clubs, strolling mothers, hip-hop, music lessons, baby-sitting classes, karate classes, and kid activities are also available to the public. There is the new E-Team, which teaches people about the sports entertainment craze that is sweeping the nation. One can also learn dance steps from one of the nation's top choreographers, KoKo Hunter.

One of the most popular events of the city is the annual Salsa under the Stars, which takes place at Pacana Park. More than 10,000 residents line up to sample 40 different varieties of salsa at this event. For kids, water zones, bounce houses, and face painting are available. For adults, there is a beer garden, a variety of food vendors, and a live band. Lucy Aviles Rodriguez was the Best Overall Salsa winner at the city's first salsa event in 2005.

The Moms Club is a support system for young stay-at-home moms. This club offers friendship and support for its members. Members of the club are very much involved in serving at schools and children's hospitals, and their fund-raisers fulfill community needs, too. These dedicated parents also set aside plenty of time for relaxing in the park with their little ones.

Maricopa has talent galore, and this talent often benefits others. The Sisterhood of the Traveling Quilts, a group of women who meet on a regular basis to make and gift quilts, shared some of their creations at the City of Maricopa Library in 2010. One group of quilt makers donated 130 comfort quilts to the police and fire departments in 2008. They also donate to Celebrate Life Family Support Center, which helps children involved in cases of abuse, fire, or accident. (Joyce Hollis.)

The 'Copa Seniors organized in 2009 in Maricopa. This group of feisty seniors started as a group of 12 and has grown to more than 100. They have get-togethers, field trips, "senior proms," potluck dinners, and line dances, and they play a variety of board and card games. Members also celebrate holidays together, such as Easter, when they hunt for eggs that promise a prize. (Joan Koczor.)

In October 2009, the Maricopa Veterans Center opened in what had been previously the Maricopa City Library. The picture was taken during the first ceremonial flag-raising event in that month. The Maricopa Veterans Center is home to the Veterans of Foreign Wars (VFW) Post 12043 and the American Legion Post 133. Both of these veterans organizations are committed to patriotic, civic, and community service programs. The motto of the Maricopa Veterans Center is "Service to our Community." The building was originally constructed in the mid-1930s as a headquarters building for Williams Air Force Base. When the base closed in the mid-1940s, it was moved to Maricopa with the purpose of housing a library. (Jack McLain, Commander, American Legion Post 133.)

The first Miss Maricopa Pageant took place at Maricopa Wells Middle School in October 2010. The City of Maricopa, chamber of commerce, and Party Productions sponsored the event as part of the city's annual Stagecoach Days. Seventeen-year-old Camilla Cochran won not only the crown but also a modeling and acting contract, $1,000 scholarship, and several other prizes, including the honor of reigning as the first Miss Maricopa. The six contestants also included first runner-up Jennifer Turley, 17; second runner-up Zulema Espinoza, 18; Alyssa Mitchell, 18; Morgan Rainey, 18; and Caitlyn Snow, 17. (Miss Maricopa Pageant.)

Twelve-year-old Austen Pearce and his mother, Marlene Pearce, traveled to Washington, D.C., the first week of May 2010, where he was named one of the top five national volunteers at the 15th Annual Prudential Spirit of Community Awards ceremony, receiving $5,000 for his 100-plus volunteer hours. These hours were spent designing, growing, and tending a community garden that provided over 14,000 pounds of fresh produce in two seasons for the F.O.R. (Food Opportunities Resources food bank). He also volunteers at the Maricopa food bank. In addition, he received $5,000 to donate to the food bank. Pearce latched onto the spirit of giving in the third grade in 2005, when he heard his teacher talking about Katrina and urging everyone to help by bringing in his or her change. Austen brought in his entire savings, which was $36. "I never did any of this to gain recognition; it's just for the good feeling of helping others," says Pearce. (Austen Pearce.)

www.arcadiapublishing.com

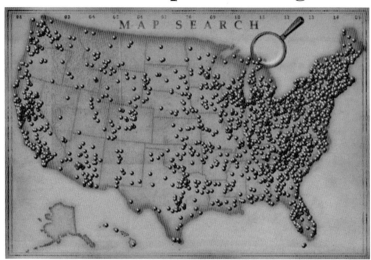

Discover books about the town where you grew up, the cities where your friends and families live, the town where your parents met, or even that retirement spot you've been dreaming about. Our Web site provides history lovers with exclusive deals, advanced notification about new titles, e-mail alerts of author events, and much more.

Find Your Place in History.